PAINTING

EXPERT ANSWERS
TO THE QUESTIONS
EVERY ARTIST ASKS

TRICIA REICHERT

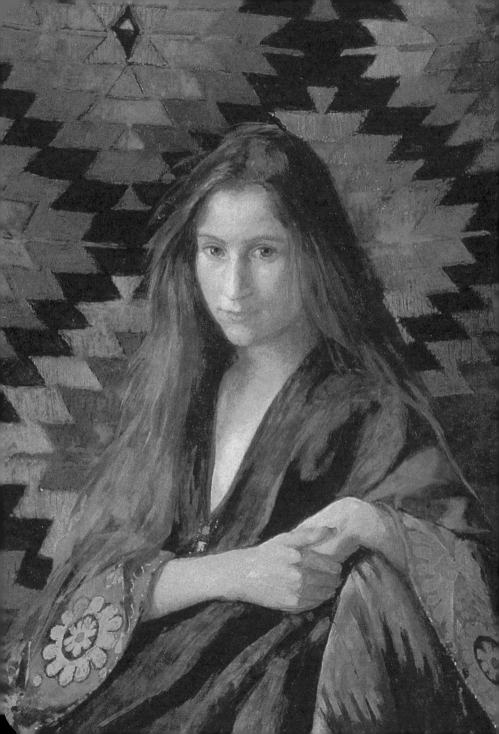

PAINTING

EXPERT ANSWERS
TO THE QUESTIONS
EVERY ARTIST ASKS

TRICIA REICHERT

A Quantum Book

Copyright © 2013 Quantum Publishing

First edition for the United States, its territories and dependencies, and Canada
published in 2013 by Barron's Educational Series, Inc.

All inquiries should be addressed to:
Barron's Educational Series, Inc.
250 Wireless Boulevard
Hauppauge, New York 11788
www.barronseduc.com

ISBN: 978-1-4380-0266-8

Library of Congress Control Number: 2012951693

This book is published and produced by
Quantum Books
6 Blundell Street
London N7 9BH

QUMAAPT

Publisher: Sarah Bloxham
Managing Editor: Samantha Warrington
Consultant Editor: Tricia Reichert
Editor: Julie Brooke
Assistant Editor: Jo Morley
Design: Andrew Easton
Production Manager: Rohana Yusof

Printed in China by Midas Printing International Ltd.

9 8 7 6 5 4 3 2 1

The material in this book has previously appeared in: *How to Draw and Paint Portraits*
by Stan Smith, *Drawing and Painting Portraits* by John Devane, *Painting Portraits*
by Jenny Rodwell, *An Introduction to Painting Portraits* by Rosalind Cuthbert,
You Can Paint Portraits by Patricia Monahan.

Contents

INTRODUCTION

Introduction

By Tricia Reichert

"Painting someone's portrait is, of course, an impossible task. What an absurd idea to try and distill a human being, the most complex organism on the planet, into flicks, washes, and blobs of paint on a two-dimensional surface".

David Cobley, portrait painter

Painting a portrait may initially seem daunting but, as the examples in this book show, you can develop the skills needed to create beautiful portraits. This collection of questions and answers is intended to inspire you, and lead you through the techniques and processes that will help you to develop and improve your own portrait painting.

A good portrait does not merely record an individual's features, it allows a glimpse of the character and personality of the subject. One look at the *Mona Lisa* by Leonardo Da Vinci or *The Girl with a Pearl Earring* by Jan Vermeer shows how a portrait can have a powerful and lasting appeal.

The traditions of portraiture appear extensively in ancient Greece and Rome where lifelike depictions of distinguished men and women appeared in sculpture and on coins. Then, after centuries in which generic representation had been the norm, distinctive portrait likenesses began to reappear in Europe in the fifteenth century. This resurgence of portraiture became a significant expression of the Renaissance in Europe.

In the nineteenth century, the camera caused many artists to re-examine the purpose of painting, and manufactured paints became widely available. Artists explored the possibilities of these. Realistic depictions of scenes and people remained popular in the twentieth century, but artists also searched for originality and freedom of expression.

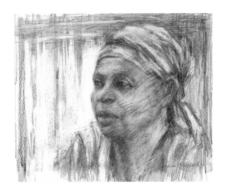

Above: *Tricia Reichert,* African Headscarf, *(Pencil). This was made using a 6B pencil with crosshatching and directional strokes. An eraser was used to lift out tone to achieve a loose surface quality.*

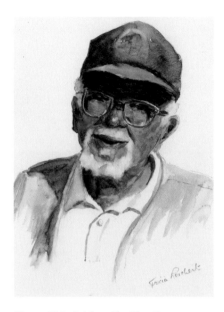

Above: *Tricia Reichert,* The Blue Cap, *(watercolor). In watercolor, black skin can be simplified by using just a few colors.*

Portrait painting derives great benefits from this historical progression.

The choices of presentation can be narrowed down to whether to paint a formal or informal portrait. A formal portrait is usually commissioned by the sitter. An informal portrait allows unlimited options to explore the likeness and character of the subject.

Traditionally, oil paint has been the preferred medium for portraiture: It allows fine detail and blending to achieve realistic skin tones. Today, acrylic paint is becoming popular because of its ease of use and fast drying capabilities.

Watercolor is more suited to expressive sketches and a looser application of tones in the face than acrylic or oil. Soft pastel is enjoying a resurgence because it can rival oils in surface quality, ease of use, and longevity. Drawing and sketching—the foundation of any artist's vocabulary—remain a fundamentally important part of every artist's skills.

In painting portraits, you don't have to include every minute detail that you can see. Simplicity, and your own approach, may give a more satisfying result than trying to photographically render every hair on your subject's head. Every portrait is a combination of the choices of both the artist and the subject. Learn as much as you can from the answers here, use the medium you enjoy most, and develop your own style.

Wishing you every success in your painting endeavors,

Tricia Reichert

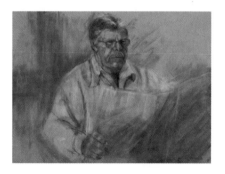

Above: *Tricia Reichert,* Reading, *(Pastel). The background paper color is evident in the background of this study.*

1

PROPORTIONS, CHARACTER, AND LIKENESS

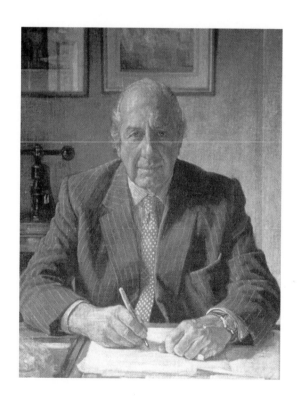

Why is it important to understand anatomy for portrait painting?

Portraiture is infinitely easier if you have some idea of what lies beneath the face of the subject. Obviously it is not necessary to remember the name of every bone and muscle, but a working knowledge of how they function and their effect on the external form and shape of the subject can be a great help.

The sketchbooks of Leonardo da Vinci demonstrate a depth of understanding and knowledge of the human body which was unique in his own lifetime and which few artists possess today, despite the advanced technical and medical material now available. Leonardo's faces reflect a lifelong interest in anatomy, and the deep sympathy and humanity of his portrait drawings and paintings are more a product of an accurate understanding of the underlying structure than of any inspired insight into his subjects.

Facial expressions are not "stuck" onto the surface of the face. A smile or grimace cannot be portrayed by merely making the corners of the mouth turn up or down. These expressions are muscular movements which affect not only the mouth, but the whole of the face, so to paint a convincing smile, you must also paint a smiling jaw, nose, eyes, and forehead! And to do this, you must understand the muscles that lie beneath the surface of the skin.

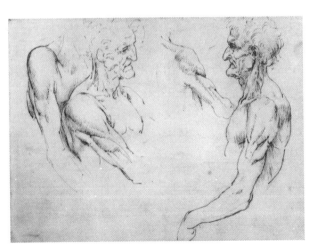

Left: *Leonardo da Vinci's drawings of the* Head and Shoulders of a Man *reveal a process of scientific and artistic inquiry. Anatomy was a lifelong interest and he refused to accept any fact or theory until it was substantiated by his own discoveries. Many of his drawings were the result of his own observations of dissections.*

What are the proportions of the head and face?

In a typical adult, the eyes are about halfway from the chin to the top of the head. Many beginners make the eyes too high, so check these carefully.

The inside corner of the eye aligns with the outer edge of the nostril on a vertical axis and, again on a vertical axis, the corner of the mouth lines up with the inner corner of the iris —if the person is looking straight ahead. The lower part of the face, from the chin to the base of nose, measures about the same as the area from the base of the nose to a point between the eyebrows above the bridge of the nose.

On a horizontal axis, the eyes are usually separated by a further eye's-width across the bridge of the nose. Also, the ears are generally level with the nose, although this generality is often very different in the flesh.

The diagrams below show how small a space on the total surface area of the head is taken up by that triangle created between the corners of the eyes and the chin—less than one-eighth of the whole. And look at how much expanse of cheek there is between this triangle and the ear, especially when the head is viewed in profile. (*See also pages 16 and 17.*)

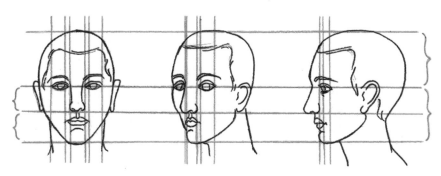

Above: *Three drawings showing (left) the proportions of a typical adult head, (center) the effects of foreshortening in a three-quarter view, and (right) a profile view.*

Can I use the same proportions for children's heads?

With babies and children, things are somewhat different. In a very young baby, the features are even smaller in relation to the whole head. Thus, the eyes are set perhaps two-fifths up from the chin, three-fifths down from the top of the head. The eyes are wider apart, but this does not mean that they are closer to the sides of the head—on the contrary. The space between the outer corner of the eye and the side of the head is likely to be broader in relation to the eyes than it is in an adult. The baby's head is covered with a layer of fat which softens its contours and gives it a rounder appearance. As a child grows its skull lengthens and the features become larger. The nose begins to take on its adult shape and the mouth lengthens and loses its rosebud roundness. (*See also page 103.*)

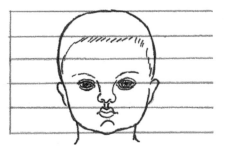

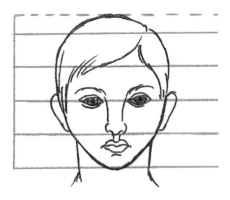

Above: *Two drawings showing the proportions of a new-born baby's head and the head of an eight-year-old child.*

ARTIST'S TIP

For children under six or seven it will be easier to draw and paint the portrait primarily from photographs. You will need to turn off the flash on your camera and take many photos with a good light and shadow pattern. Take profile, full-face, and three-quarter views to capture the shapes and expressions of your subject's face.

Are there any more tips for drawing and painting children?

Making portraits of children involves a number of particular problems. Most children do not make ideal sitters; younger ones are usually fidgety and unable to hold a pose for long. While older children can be eager to cooperate, they may lack the concentration necessary for a prolonged sitting.

Practice making quick sketches will enable the artist to capture fleeting movements: these can be assembled to provide reference for a more finished work. For a formal pose, it may be possible to alternate short periods of drawing with rest breaks. Even more crucial for children is the choice of a pose which is not only natural and characteristic, but comfortable as well. Children asleep or playing also provide good opportunities. If other methods do not work, draw from a photograph.

In general, pay special attention to the differences in skin texture, proportion, and anatomical structure between children and adults, and choose a medium that will help to maintain a degree of lightness and vitality.

Right: *Jerry Hicks,* Lara *(oil on board). This girl, who is eight years old, stands five-and-a-half head-lengths tall. Her knuckles are halfway between her shoulders and her feet.*

What is meant by the three-quarter view?

The three-quarter view is halfway between a profile and a full-frontal portrait, and often creates a less direct, more dimensional impression of the subject than a full-frontal pose or profile.

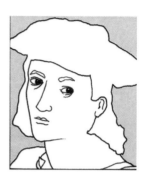

Right: *The three-quarter view is the traditional pose for portraiture. It has been used extensively because it incorporates as much of the full face and profile as possible.*

How can I measure the face?

When drawing the head, start with an overall egg or oval shape and locate the horizontal center line. Now you can plot the position of the eyes in relation to the head's length by measuring the top half, (top of the head to bridge of nose) against the bottom half (bridge of nose to chin). An eye or nose-length is another useful unit of measurement. See pages 11, 16, and 17 to locate the positions of the other features. Be sure to carefully observe all the angles and shapes that you see.

Below: *A preliminary pencil drawing establishes the position of the head and shoulders on the rectangular support. The features are drawn accurately at this stage.*

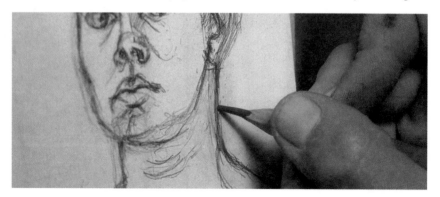

What is foreshortening?

This is the effect on the features when the head is turned away, tilted, or viewed from above or below. We have already seen that the face is set into a curved surface and that as it turns away from us the features undergo dramatic changes in appearance, the far eye, cheek, and side of the mouth becoming compressed. When viewed from above or below, things are also somewhat altered.

The effects are easy to see in a mirror. If you tilt your head down and look at yourself from under your eyebrows, you will notice first of all how much more of the top of your head is visible and how much less of your face: the whole face becomes fore-shortened. The nose may overlap the mouth, the chin disappears, and most dramatically of all, the ears are suddenly much higher than the nose. In an upward tilt the reverse happens.

These are extreme examples of a much subtler effect in most portraiture, but should your sitter's eye level be higher or lower than your own, you need to know the effects this will have on what you are seeing. After all, it is usual for a sitter's head to be tilted or turned in some way.

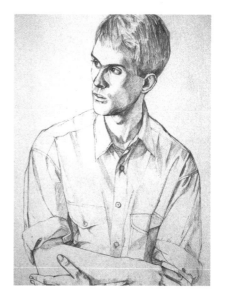

Right: *Ivy Smith,* Simon Mills *(pencil). The subject's head is turned and tilted. As we are looking slightly down on his face, the top of his head is turned toward us and the space between his eyes and eyebrows has almost disappeared. Because his head is turned away we can see all of his cheek, and the side of his nose. His far eye is partly eclipsed by his brow and nose, and the far side of his mouth is turned steeply away from us, compressing its shape.*

How far apart should the eyes be?

The eyes are usually one eye-width apart and the nose-width fits between them. If you draw or imagine a vertical line up from the outer edge of the nose it will help you to locate the inner corner of the eye.

Where will the eyes be located in a profile pose?

The same vertical and horizontal feature location lines that you saw in the proportion diagrams apply to profiles (*see page 11*). The inner corner of the eye still lines up vertically with the outer edge of the nose, but in a profile view the inner eye corner will often be hidden from view. (*See also page 94.*)

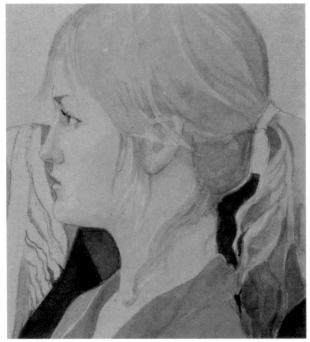

Left: *In this profile portrait the head fills the rectangular picture area. This forms a series of abstract shapes around the subject, creating a tightly arranged composition with a deliberate lack of empty space around the head.*

How wide is the mouth?

The outer corner of the mouth generally lines up vertically with the pupil of the eye, even if the face is in a profile or three-quarter view. In a three-quarter view the far side of the mouth and the eye will be shorter. (*See also page 101.*)

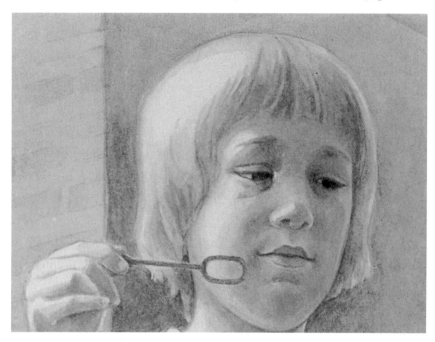

Above: *In this portrait you can see that the overall width of the mouth is approximately as wide as the distance between the pupils of the eyes.*

What is a sight-size portrait?

A sight-size portrait is a portrait that appears, from where the viewer is standing, to be exactly the same size as the model.

You can achieve a very accurate drawing from life by measuring the model and transferring those measurements to your canvas.

How can I make my portrait fit the canvas?

Measuring with your pencil is the best way to ensure that you are placing everything in the correct place in your initial drawing.

Begin by holding a pencil vertically in front of your model. Making sure your arm is fully extended and, if necessary, supported at the elbow to prevent it from wobbling, move the pencil tip until it is level with the top of your model's head. Close one eye or you will see two pencils. Now, move your thumb up the pencil until the top of it is level with the bottom of your model's chin. This gives you one head-length marked out between pencil tip and thumb tip. Next, move the pencil down until its tip is now where your thumb was. You should be able to see your thumb's new position one head-length lower. Making a mental note of that spot, lower the pencil again to mark off a third head-length and so on, continuing until you have covered the whole pose. It may occupy five-and-a-half head-lengths.

Next comes the problem of transferring this information to paper or canvas. How large or small you make it is up to you. The best way to decide is to divide your picture surface into, say, five-and-a-half equal units, leaving enough room at top and bottom or you will find your subject touching the top and bottom edges of your paper. Each unit represents a head-length. The diagram below shows how to follow this method to transfer scale to fit.

Once you are used to marking off head-lengths in this way you will find it easy to use other sections of the pose to make checks both vertically, horizontally, and diagonally—in fact, in any direction necessary. For instance, a head-length can be turned on its side (turn the pencil, thumb in position, through ninety degrees until it is horizontal) and used to check the width of the pose, the position of an elbow or hand, or the length of an arm.

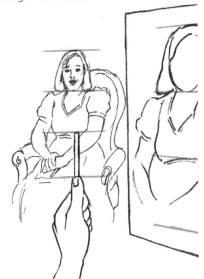

Above: *Drawing showing the artist measuring the model and enlarging the scale to fit the canvas.*

How large should I make the face in my portrait?

Portraits usually look better smaller than life-size, but you can work in any size that feels comfortable to you.

The role of preliminary sketches is twofold. Their main purpose is to work out certain aspects of the portrait before starting the final work. They can also be a valuable reference to be used in the absence of the actual subject. Some artists work entirely from drawings and sketches, needing only one short session with their subject to complete the work.

To a certain extent, finding a successful composition is a matter of trial and error. Small drawings, sometimes called thumbnail sketches, are a useful device. Make a number of these, trying out various arrangements and different ways of composing your subject. Each drawing may take only a few seconds and will help you to work out a satisfactory composition for the final portrait. You will possibly want to take elements from different drawings, preferring the position of the hands in one, the type of chair in another, the angle of the head in a third, and so on.

Sketches can also help you to decide what scale your subject should be. A larger drawing may also be useful here. Make a rough sketch of the subject, allowing plenty of space all around. Take a piece of cardboard and cut a hole of

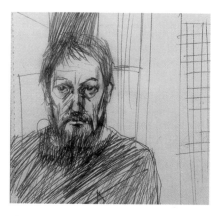

Above: *Most portrait artists work from a reference at some stage during a painting. Many make preparatory black-and-white drawings, or quick color sketches. Others rely on photographic reference.*

the same proportions as your support and use this as a viewfinder. By moving the window you will be able to see the best position for your subject. Try windows of various sizes and shapes to help you decide how much background to include and what shaped support would be best for the purpose.

Many artists make elaborate sketches. Some even produce color "sketches" which are almost indistinguishable from the finished painting, differing only in the amount of detail and blended finish which is included in the final picture.

Do I have to start with a pencil drawing if I am going to paint the portrait?

The first hurdle in designing a painting is to be able to place things exactly where you want them. It is no good creating a beautiful portrait if the head is too low in the picture, leaving a surfeit of fresh air overhead; or if the hands or feet are cut off awkwardly or—worse still—squeezed in somehow.

If you have difficulty with this, it is well worth practicing just the business of placing a figure, or a head, on the support, so that you are in control when it comes to designing a painting. Measuring is a useful tool here (*see page 18*).

The initial drawing can be made in paint, charcoal, or pencil for painting the portrait. Some artists prefer to make a very detailed drawing and others choose to start with a looser interpretation of the face and features. At this stage, as well as drawing the main outlines, you can also indicate the main areas of light and shade.

Above: *The artist started by making a fairly detailed drawing using charcoal.*

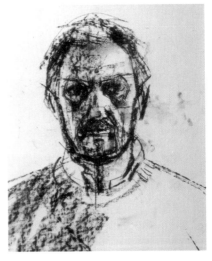

Above: *Here the artist started with a drawing of thinned burnt umber paint.*

How can I achieve a likeness of my subject?

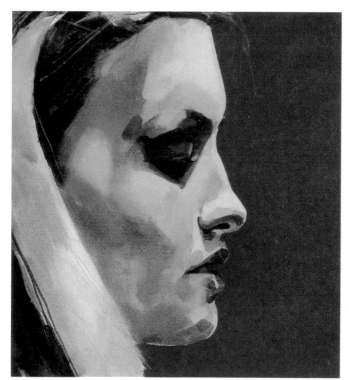

Left: *A strong light and shadow pattern on your subject will not only help you to achieve a good likeness, but will also give a more three-dimensional feel to the profile portrait.*

The ability to "get a good likeness" is often thought of as something beyond the mere technical skill of the artist, a sort of heaven-sent gift which exists independently of artistic talent and which has more to do with some mysterious insight into the character of the subject than with being able to draw or paint a face.

Portrait painters are usually the first to refute this. Although a good likeness is not entirely a question of correct proportions, technical ability and experience have much to do with it. Obviously it is helpful to be able to pinpoint special characteristics and to know the idiosyncratic gestures peculiar to your subject, but the actual "likeness" is something which emerges naturally, an indirect result of close observation and your ability to paint what you see.

Are there any other ways I can ensure a likeness?

Many portraitists believe that starting with a consideration of the whole structure of the head and face is vital to a successful rendition of an individual with the features judged only as parts of the whole and incorporated gradually. This method involves careful observation of the shapes of the shadows, lights, and features within the overall head shape.

The question of what makes a good likeness is impossible to answer. If ten painters gathered around a single sitter, their differing styles might produce radically different images, each of which might also be a good likeness. Assistance with finding a likeness will be found in the early chapters of this book, and the importance of drawing cannot be overstressed. Regular practice with pencil, conté, or charcoal will help train the eye and develop fluency of line which will translate into fluency of the brush in painting. It is always educational to study the drawings of the masters.

The artist aimed for luminosity and a fresh approach in this study of *Barbara*. Follow the steps to discover how to create the same affect.

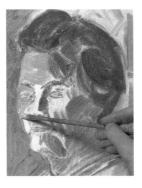

1 This painting in oils uses a white ground. First, decide on the size and position of the head, using viridian thinned with turpentine.

2 Then explore the likeness and develop some modeling. Here a mix of raw umber and burnt sienna was used. The artist continued to work very thinly.

3 Brush in a background color of raw sienna and then begin applying the flesh tint, mixed with titanium white, cadmium red, and a touch of raw sienna and cobalt blue.

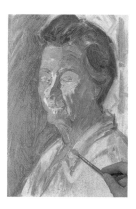

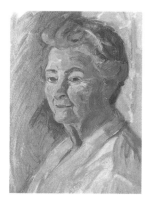

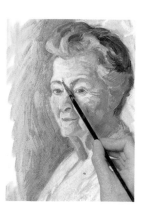

4 Still working broadly, adjust the half-tones using some of the flesh tint and adding more raw sienna and cobalt blue.

5 Strengthen the features and catch the expression using cadmium red, cobalt blue, and white. At this stage the likeness and modeling are established but the treatment is still very rough.

6 Now add lighter values to the flesh tint using white, cadmium red, and lemon yellow. The cheeks and chin are warmed by the addition of a little carmine.

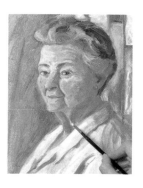

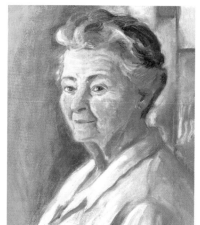

8 Using raw umber and burnt sienna, deepen the background around the pale hair, face, and blouse, and add a final touch of light on the ear.

7 Touch in the ear using a mixture of raw umber, cobalt blue, and cadmium red. Cheek and neck are further developed and white highlights added to the eyes.

How does the expression of the subject affect the features?

Tiny muscular movements in the face enable us to express an enormous range of feelings. Most of these are made involuntarily, and it is difficult to fake them, as the pretence is also visible on the face.

A range between laughter and quiet amusement.

1 When laughing, deep creases appear in the skin and the features are elongated.

2 When the head is tilted back, movement is implied while the facial muscles are less taut.

3 Progressively more serious, the face loses its lines.

4 The eyes become rounder.

A range of subtle expressions.

1 An ambiguous lifting of the corner of the mouth could indicate a question, but the eyes seem to show cynical amusement.

2 The intense stare is due to the model staring into the camera; otherwise it is an unemotional expression.

3 Downcast eyes seem to imply doubt or shyness.

4 The sideways angle and unequivocal stare are suspicious.

The emotions of distrust, anger, and disgust.

1 The angle of the head is important as is the shape of the eyes, the size of the pupils, and the placement of the pupils within the eye.

2 The shape of the mouth also plays a part.

3 The way the skin is pulled over the cheekbones signify age as well as feelings.

4 Creases beside the mouth are a good indicator of extremes of emotion or of age.

How can I add character to my portraits?

We feel character in portraits rather than necessarily seeing it. A sense of the personality of the subject, a charm, an appeal—in particular, a quality beyond the actual likeness of the person. The pose and expression of the sitter can add character, as can the composition. For example, in his painting of *Dr. Gachet*, Vincent van Gogh exploited the descriptive character of his brush strokes to emphasize the forms of the face to create an intelligent, bright-eyed portrait.

Right: *The full-faced centered portrait is perhaps the most direct way for the artist to present his subject. The effect can be strong yet subtle.*

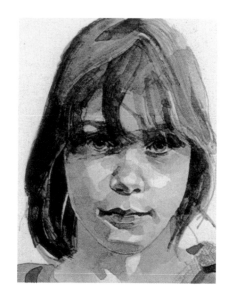

What are angles and why are they important?

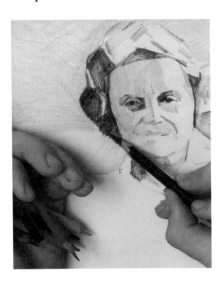

Angles are the slopes and tilts of the various features of the face and body. Carefully observing them will help the likeness in your portrait.

After you have laid out the proportions and placement of the features, carefully observe the angles in your subject. In the face, look for the angles in the eye shapes, ears, eyebrows, mouth, and jaw line. In the body, look for the angles in the shoulders, muscles of the neck, arms, and hands, and clothing shapes.

Left: *Initially drawing all shapes with angular straight lines will give a strength and solidity to the drawing.*

Should I make a sketch of the subject or a full painting?

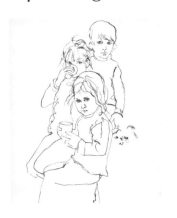

A successful portrait can be achieved with either a quick, informal sketch, or an elaborate oil painting. In this pen-and-ink sketch, we see how the skilled handling of line capture the mood and personality of the sitters.

Left: *This group portrait is composed in the shape of a triangle, with the poses of the children suggesting a mixture of curiosity and shyness. It is executed in pen and ink, with light smudges to add tone and texture.*

I don't have a model to pose for me but I want to paint faces; what can I do?

Self-portraits are a really good way to practice your drawing and painting skills from life. Working from good photographs with strong light and shadow patterns is another option.

Because the history of portraiture is studded with so many fine gems, to find one's own language and to avoid the pitfalls of sentimentality and deadness is often difficult. Many artists use the self-portrait to guarantee a consistent model and to allow a subject for experiment, both with descriptions of form and the way of approaching problems.

Throughout the centuries, man has ventured to create images of himself, often using the self-portrait as a background figure or as a character in animation. The self-portrait as an art form, in its own right, was taken to very high levels of achievement by Rembrandt, Van Gogh, and Cézanne, all of whom used it to discover their personal means of picture making.

For example, van Gogh's aim was not to use colors to reproduce visual appearances but to express, and cause, emotion. He suffered from depressions and hallucinations and used thick, swirling paint in one self-portrait to express this mental anguish.

The self-portrait remains an extremely useful way to gain knowledge and will give aspiring portraitists valuable opportunities to experiment and risk making mistakes.

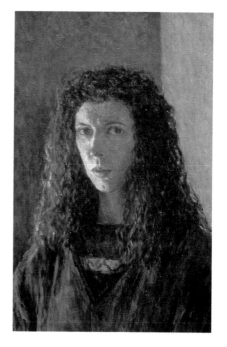

Right: *Helen Elwes,* Self-portrait—detail *(oil on canvas). In this three-quarter view, the near side of the nose is barely darker than the cheek. Light on the nostrils and along the edge of the nose is perfectly judged. Without these touches, the nose would remain flat. This painting was inspired by a famous self-portrait by Dürer.*

2

LIGHT AND SHADOW

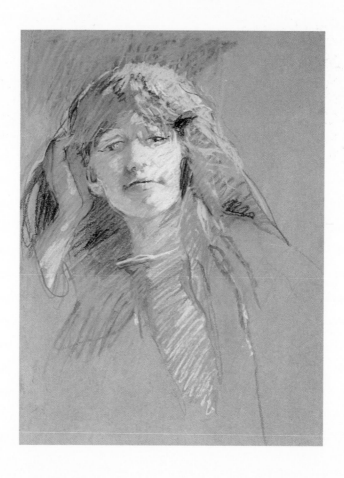

What do you mean by light and shadow?

The light source in a painting is most realistic if it mimics sunlight. When light illuminates the surface of an object, it also creates shade. If the light is soft and diffused, the shadows will also be soft and with no great difference between lit and unlit areas. But if a bright light is shone onto the side of a face, it will dramatically illuminate it, casting the other side into deep shadow. The way a subject is lit is important in deciding the mood of a picture.

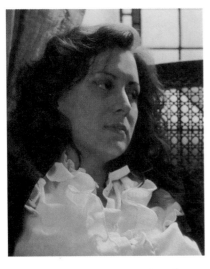

Above: *Turned towards the window, the form of the face and features are clearly defined by the daylight.*

Above: *When the model turns her face the other way, the features are lost and the face flattened into a dim, shadowy shape.*

How can I better understand light and shadow tones?

You can practice on middle-toned paper. Use vine charcoal, or black or sepia conté crayon; a white pastel pencil or conté crayon; and a middle-tone gray pastel or charcoal paper. Lightly draw in the darker areas of the face, then add the lighter areas with white. Leave the paper tone for the middle tones.

How else can I build up tone in my sketches and drawings?

These three works show different methods you can try.

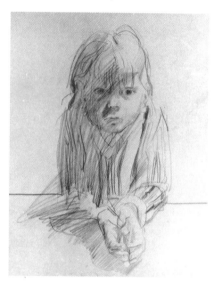

Above: *The hands have been emphasized, almost to the point of distortion, to give a foreground focal point and increased depth.*

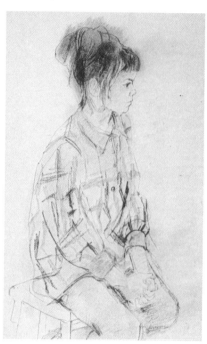

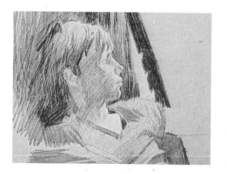

Above: *Ragged, sketchy lines applied with acrylic paint give an added dimension to the pencil work of the drawing. The head and cuffs are emphasized to bring out the pose.*

Left: *This shows how a systematic build-up of lines can create the impression of tone and form. This is the opposite of using line to imply volume by tracing the contours of a shape. It works best using colored pencil.*

What is the best way to light the model?

North light is natural light at its most constant, and this is why artists are often careful to choose a north-facing room for a studio, or to install north-facing roof lights. A single light source using artificial light is a good alternative to north-facing windows if your painting space does not have a northern aspect.

Most portraits are painted indoors and usually the sitter is placed near, or at least out of, direct sunlight. The softness of natural light is very beautiful and light filtering through a window onto a face will disclose its qualities gently and truthfully. Rembrandt lit his subjects from a high angle, producing a spotlight effect; meanwhile, Holbein favored light entering at a level close to that of his sitter's eye-level.

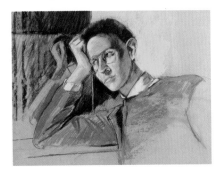

Above: *A single directional light source was used in this pastel painting.*

What type of lightbulbs should I use to light the model?

Modern fluorescent "daylight" bulbs are an excellent substitute for the real thing. They can be used in place of natural lighting, or can be arranged across a window and used to replace the daylight as it fades and changes.

Artists who depend solely on artificial lighting often use a strong main lamp and supplement this with fill-in lights to counteract the strong directional beam from the main source.

An alternative method is to use a main light source and reflector screens—sheets of a white material which produce a soft, reflected glow on the subject's face. By placing a screen opposite the main light source, you can illuminate one side of the face quite dramatically and use the screen to gently light the other side, thus avoiding harsh contrasting areas of light and shade.

Is it a good idea to paint the portrait outside in the sunlight?

Direct sunlight is a problem for portrait painters as it sharpens tonal contrasts and because it is never still. It is possible to paint from light in direct sunlight, but I would advise you not to try this too soon. Wait until your skill has increased and you are able to complete a portrait quite quickly. There is nothing more frustrating than to be halfway through a portrait and find that the light has changed, altering all the color relationships; and even a small shift in the light is enough to create confusion.

The beauty of sunlight is that it increases the amount of reflected light, bouncing back onto your sitter's face from surrounding sunlit surfaces. Something of this effect can be achieved indoors using artificial light.

A single light source can be rather dull, flat, and colorless.

It is possible to include a floor spot light on the same side of the model as the window and hang a colored drape, e.g. yellow, on a screen on the other side. This effect will transform the subject and lift the mood of the painting. Warm golden light will bounce into the shadows, giving more possibilities for color and shape.

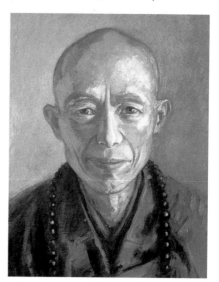

Above: *Ros Cuthbert,* Master Sheng Yen *(oil on board). Light from the yellow wall transforms the half-tones of the sitter's face.*

> **ARTIST'S TIP**
>
> If you want to work from photographs taken on a sunny day, you will have to make allowances for the shift of color and tone in the shadow areas in your photographs. They will appear to be much darker and colorless in the photo than they are in reality. Painting from the image on your computer screen will give you more light and shadow information than working from a printed photo.

Are there any other ways to make the light more interesting?

Another possibility is to use two light sources. A favorite device of mine is to place my sitter near a window and shine a small table light—one which can be angled to give just as much or as little additional light as I need—on his or her dark side.

Natural north light is cold, but artificial light is often quite warm, producing golden or honey-colored hues. Sunlight, too, produces warmer colors than north light. This warm-cool light contrast provides wonderful opportunities for a varied palette.

Far left: *Strong artificial light from one side creates hard-edged shadows. Hang a white cloth on the opposite side to soften it and reflect soft light onto the shaded side of the face.*

Left: *Without this the result can be ghoulish and unattractive.*

What is meant by *chiaroscuro*?

The term *chiaroscuro* is an Italian word that simply means light (or clear) and dark (or obscured).

In painting, this term is used to talk about paintings that have a very strong light and dark pattern. The effect can be seen in paintings by many of the old masters, in particular Michelangelo Caravaggio (1573–1610), who used an

emphatic balance of light and shade (*chiaroscuro)* to create movement and volume in his painting. The technique is known as *chiaroscuro* (in French it is *clairobscur*) and the portraits and figures created in this way often seem to have been literally sculpted out of a dark, shadowy background and to catch the light as they come to the surface.

How can I achieve the look of *chiaroscuro* in my portrait drawing and painting?

Working on a dark toned surface can help achieve a strong feeling of light and shadow in the portrait. This pastel portrait shows how this can be done. (*See page 91.*)

Right: *Emphasis is placed on the face and hand. The flesh tones become more substantial and a rich surface pattern is built up through the use of a variety of colors. The flexibility of pastels as a drawing medium means that they can be used alternately to delineate and shade. Here, the bulk of the shoulders is suggested by the simple application of strokes of blue, with gaps left between them to reveal the color of the paper. Blue lines also serve to fix the contour of the figure. The artist uses colored pencil for finer detail, in the shadow areas under the eyes, and around the mouth. Rather than applying a range of neutral tones, green and blue strokes are used and merge with the paper to create richness and add volume and depth.*

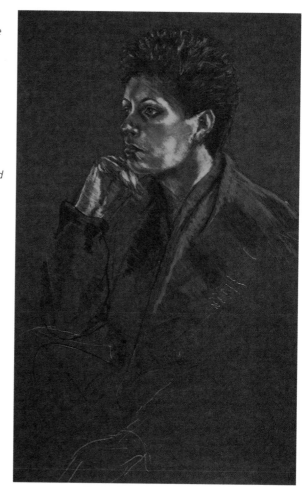

What is reflected light?

Take care not to paint the reflected lights too light in your portraits. Reflected light can affect both directly lit and shadowy sides of your sitter's face, though on the lit side it is not usually visible as such. However, if light is reflecting onto the skin from a brightly colored surface, it will carry that color with it. This has a transforming effect. We have all, as children, held a buttercup beneath a friend's chin to see whether they "liked butter." Invariably they did. If the reflected light is red, it will dramatically warm the normally cool tones in shadowy areas. Thus, a red dress or shirt can have a profound influence on the half tones. Blue reflected light registers as mauvish on "white" skin, an effect often present beside a swimming pool on a sunny day.

Right: *Jerry Hicks,* Bunny *(oil on board). In this painting of a young man, the dappled sunlight and his relaxed, dreamy expression create a warm and gentle atmosphere. Note the honey-colored reflected light from his chest under the chin, nose, eyebrows, and also on the upper lip.*

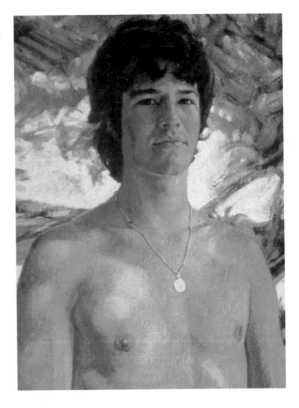

What are the differences between a form shadow and a cast shadow?

A form shadow is the shadow that is formed by the area of the face turning into the shadow side of the head. Form shadows generally have soft edges between light and shadow.

A cast shadow is usually a slightly sharper-edged shadow caused by the object, e.g. the nose, blocking the light and casting the shadow on the cheek. The cast shadow will not only describe the shape of the object that is blocking the light, but also the light direction and the shape of the surface on which it is cast.

Right: *In this portrait the artist has used the shadow shapes to help describe the face. The nose is casting a shadow onto the cheek. You can also see a shadow cast by the arm onto the hand that is in shadow and the shadow on the forehead cast by the hair.*

ARTIST'S TIP

When painting, it is important to remember that cast shadows are usually darker than the shadows found in areas that turn away from the light.

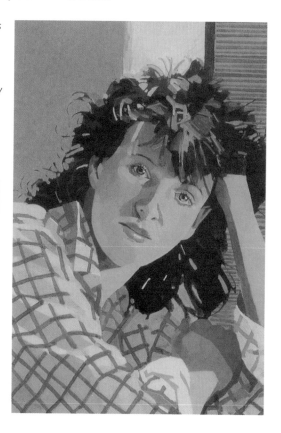

What is a half tone?

The tones in the face can be simplified for painting into three main areas: highlights, flesh color, and shadow area. The half tones are the varied flesh tones between the darks and the highlights.

Every shadow and highlight has its own color which will be affected by the reflection of surrounding colors. Flesh tones are a subtle mix of light and dark, and warm and cool.

All portrait painters use shades of green or blue, sometimes both, for the elusive cool shadow tones present in all skin types. In the demonstrations in the later chapters of this book you will see how some artists approach the problem.

What are the highlights?

Often, the lighting in a painting can look natural, but on close observation only be the result of an intricate lighting system or the imagination. Rembrandt, who has probably had more influence on portrait painting than any other artist, used light in such a way. He introduced highlights to emphasize a contour or area of the face, regardless of logic or the probability of such effects occurring in real life.

Above: *Small touches of highlight and shadow were added with a small brush to define features such as the model's ear.*

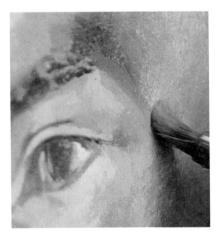

Above: *A fine sable brush was used to develop the shadow and highlight areas around the eye.*

How can lighting change the appearance of the face?

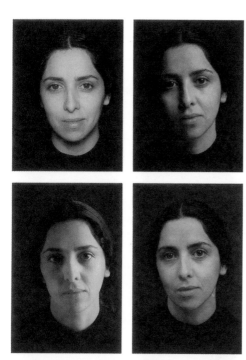

Different lighting techniques tend to become associated with the portrait painters who employ them. Bending the rules of nature is fine, and there is nothing wrong with taking a little artistic license in the interests of creating a more interesting painting, but it can be overdone. Too much fragmented light and over-zealous highlighting will soon destroy what it was intended to achieve. Instead of describing the contours and volumes, it can eventually flatten them.

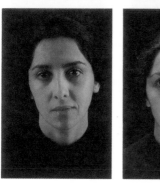

Left: *In everyday life we see the human face in a complexity of simultaneous light sources. For the beginner, it is a good idea to limit the light sources, and later to experiment by changing or strengthening them. The effects here were achieved with a combination of direct, artificial lights.*

How can I get good light in my photographs for painting?

If you are taking a photograph of a subject you know you will want to paint, it is best to take several photographs and not rely on one. If you have a manual control camera, alter the aperture to take in more, and also less, light than your light meter indicates, in case your sunlit areas suffer from burnout, or your dark shadowy areas come out black in the photograph. It is very likely that one or another of these will happen and it is difficult to imagine the colors that your camera has not picked up, but which your own eye certainly would have seen.

I also recommend that you turn off the flash on your camera for better resource photos for painting. Take your photographs in the morning or late afternoon when the shadows are longer. A single directional light source, from the sun when outdoors, or from a window if indoors, will give the best type of lighting in your photograph for subsequent portrait painting. A clear light and shadow pattern on your model will make the subject more dimensional and, as a result, the painting process will be easier.

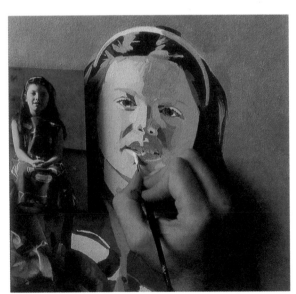

Left: *In this portrait done entirely from a photograph of a little girl in a bright colored dress, the artist chose to tone down the background, painting it in neutral colors, although a scumbling (*see page 159*) of lighter color was applied to the background surface to give an interesting texture. The texture became modified as the artist worked, but still retains a lively surface in the final picture.*

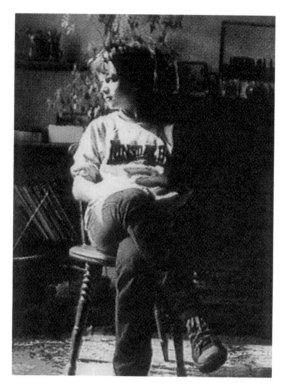

Left: *The strong directional light on the seated child provides the artist with ample opportunity to use the classical watercolor technique of allowing the white paper to represent highlights (see also page 203).*

Left: *The imposition of the strong, dark background causes some of the figure tones to look weak and faded in comparison. To remedy this, the artist strengthens some of the darkest shadows. For example, the eye and nostril have been picked out with a dense mixture of ivory black and burnt sienna.*

3

BACKGROUNDS AND COMPOSITION

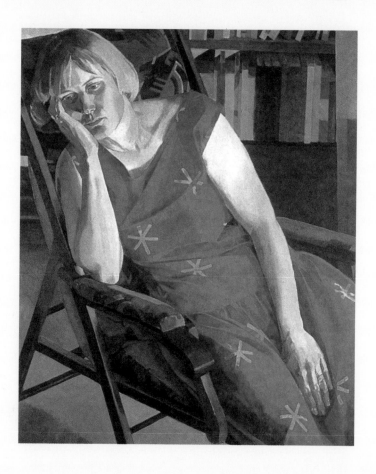

What is the best pose for a portrait model?

The word "pose" is perhaps slightly misleading in this context. It suggests a forced, rather artificial position, whereas the aim of the portrait artist is usually to get a sitter to look as natural as possible. However, it is the word generally used in all portrait and figure work to describe the way in which a subject is presented to the artist.

If your subject is sitting—or standing—in a position which does not come naturally, you start at a disadvantage, as his or her awkwardness will be reflected in your picture. It is worthwhile trying several alternative positions, asking your subject which positions feel right and which don't. A natural position will be more comfortable and will be easier to keep for longer periods of time. In the majority of portraits, the subject is looking directly at the artist. Sometimes the figure is slightly turned to offset the symmetry, but quite often a composition will consist simply of the full-frontal view of a head and shoulders. This kind of approach works well for some artists—usually those whose chief concern is with the character of the subject, and who prefer to focus their attention on the subtle color and texture of the skin, hair, and features.

Alternatively, a portrait can be painted in profile, presenting a perfect side view of the subject. This can be particularly effective if the face possesses prominent, well-defined, or otherwise distinctive features. A more natural aspect of the face is that which is usually referred to as a three-quarter view. This is halfway between a profile and a full-frontal portrait, and often creates a softer impression of the subject than either of these extremes.

Right: *The way in which a subject is lit can affect a painting in many ways. Light can change the mood of a painting and also influences the colors which can be perceived. For this painting the artist is concerned with the effect of light on the model, the way it illuminates and describes the form and at the same time dissolves it into strange and abstract shapes and facets.*

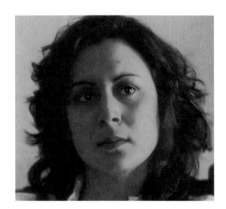

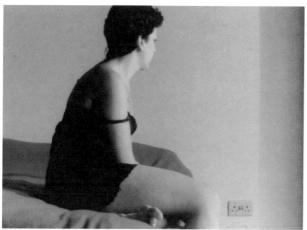

Left: *The artist has chosen an unusual pose with the model's head turned away from the viewer. It is nevertheless an acute, penetrating portrait of the subject, instantly recognizable to those who know her. The composition is simple, with the figure silhouetted against the pale and uncluttered background.*

Below: *The pose is dramatic with a strong directional light coming from one side. Dark shadow envelops half of the composition, and the contrasting arrangement of light and shade is reflected in the clothes worn by the model, especially the white turban and simple black top.*

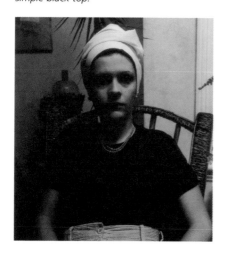

Above: *Find a comfortable position for your subject—one which looks natural and which includes enough of the shoulders and clothing to make an integrated picture.*

How can I decide where to place the figure in the composition?

Consider not only how to pose the subject but how to place the pose on the paper, board, or canvas. The whole figure could be included, or just a section. It could be placed centrally or to one side, with some of it outside the frame.

Below: *A model can be used to try out different poses.*

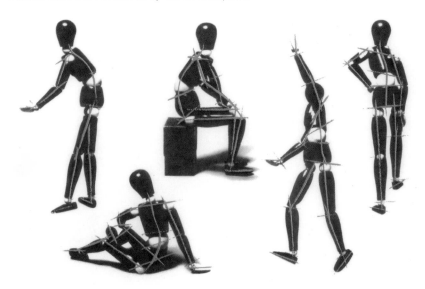

What is meant by "negative space" or a "negative shape"?

The figure is the object you focus on, and the background is everything around the figure. What is figure and what is background can change depending upon your point of view.

In this painting, the three men are the objects and the space around them is the background or negative space. However, in front of the left figure the bowl can become the object and the

figure, the background or negative space for the bowl. To the right of the bowl, the hand becomes the object and the shoulder becomes the negative shapes between the open fingers of the hand.

The head and shoulder of the figure on the right is the object and the two figures behind his head become the negative space or shape behind him.

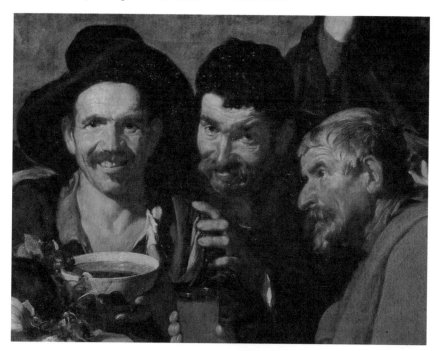

Above: *Velasquez* The Topers *(c 1629). It is always important to consider the negative shapes as positive elements, rather than empty space, to make a unified composition.*

Right: *The negative space of the background often provides the artist with an opportunity to redraw and redefine the shape of the subject. Here, the artist takes the background color to the edge of the subject.*

Can I see more examples of negative space and negative shapes?

Yes, some are shown here. You will also see more examples of negative space used in different ways in the portraits shown in the rest of this chapter.

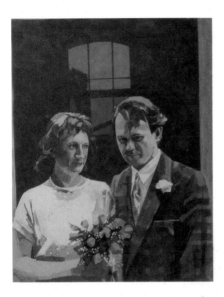

Left: *The artist developed the tonal depth across the whole painting. Flesh tones were strengthened, and dark gray shadows across the front of the groom lend a feeling of form and solidity to the subject. The groom's tie adds a dash of color.*

Below: *Steve McQueen,* Leslie *(acrylic on canvas). For this painting, the artist worked with a matte medium on a white ground. An unusual feature is the gold leaf halo. A ground of burnt sienna and crimson was laid down, and the gold leaf applied using Japanese gold size, some of which was overpainted as the painting progressed.*

ARTIST'S TIP

The acknowledgement of negative shapes will become second nature if they are considered from the start. Although there is a natural temptation to focus on the face, a pictorial unity will only emerge through a more general awareness of the space occupied by and around the figure.

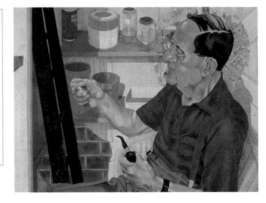

How much of the figure should I paint?

Many portraits include a large part of the figure, sometimes the whole top half of the body, and sometimes—usually when the subject is sitting—the legs as well. The main difficulty here is that because the face takes up such a relatively small space compared with everything else, it becomes lost, and you end up with a figure painting instead of a portrait.

The artist can select the frame best suited to the composition and the desired effect by using two L-shaped pieces of paper or cardboard and moving them to extend or shorten the edges (*see page 64*). You can use a digital photograph to help in composing the picture.

Mirrors are effective in portraits as they automatically show two sides of the subject and allow the spectator to glimpse something of the rest of the artist's view. (*See also page 214.*)

Right: *Composition is all-important when planning a portrait. Even when your subject is a comparatively uncomplicated one, such as a seated figure, you must decide whether to use your canvas vertically or horizontally, and how much of the figure to include in the composition.*

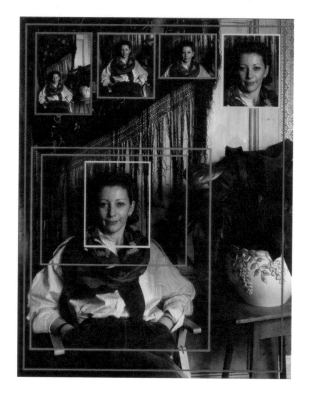

Should I include the hands in my portrait?

Hands play an important part in the composition of portraits. They echo the tones of the face, often preventing this from standing out as a stark oval, unrelated to the color and tone of the rest of the painting. And they can also be an important part of the composition, guiding the viewer's eyes according to how and where they are placed. Don't shy away from hands just because they might prove difficult. It is surprising how many artists paint hands effectively by dealing with them in the most sketchy and general terms.

Hands are important. If you are going to include them in the portrait, their position and treatment should be carefully considered. Hands can make an image seem alive, giving a feeling of movement to the pose, or they can create an informal atmosphere if they are held in a natural and relaxed way. They are, however, a focal point in the picture, and if they are badly done, there is little chance of their being overlooked.

Unless your portrait is a formal one, perhaps with the subject's hands resting on a table or desk, try to avoid putting both hands on the same level. Hands and face stand out because they are the same tone and color, and it is all too easy to create an uncomfortable pyramid effect with the head as the top of the triangle and the hands as the base. Instead, try to use the similar tones of these features to advantage, arranging the hands to complement the face and to create a harmonious balance in the composition.

Many portrait artists have developed the technique of positioning of the hands to a fine degree. For example, the figures in the portraits of Gwen John (1876–1939), almost without exception, sit with their hands together on their laps. There is nothing jarring or surprising in the composition, and the perfect relationship between the hands and face creates an atmosphere of peace and quiet intimacy.

It is almost always a bad idea to allow part of the hands or fingers to go off the bottom of the picture. The eye is immediately directed to this cut-off point and the bottom edge of the picture becomes unduly important, holding the viewer's attention when it should be concentrating on the face and the rest of the painting. For the same reason, bare arms should not be taken beyond the edge.

Hands are not as difficult as they might appear, although it often pays to practice by making some studies of your own hands. A common mistake is to attempt to draw or paint each finger separately without regard for the hand as a whole. The result invariably resembles a bunch of sausages, but if

you can first establish the planes across the hand, knuckles, and wrist—the fingers follow on naturally.

It is not unusual for hands to be sketchily treated in portraits; even in the most finished and detailed of paintings they may be represented by no more than a few well-placed brush strokes. One reason for doing this is to prevent the hands from competing with the face. We have already noted that hands tend to draw attention, and this is especially true when every finger, knuckle, and nail is rendered in minute detail—particularly if they are in the foreground of the composition. It is surprising how minimally drawn and painted hands can actually be without losing either their structure or their credibility.

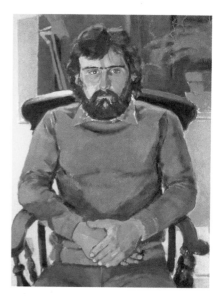

Above: *Jane Percival,* Raymond *(oil on board). The pale flesh contrasts with the dark hair and beard. Flesh tints are visible beneath the thinner beard growth. In these areas, dark paint has been scumbled over dry flesh tint.*

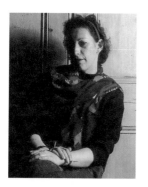
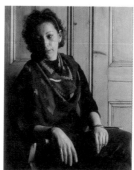
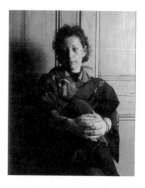

Above: *The position of the hands plays an important role in a portrait. These photographs show how the position of the hands affects both the mood and composition of the portrait.*

How can I choose a background for my portrait?

Attitudes to backgrounds vary enormously. Some artists prefer to keep the area behind the sitter as simple as possible, an expanse of neutral tone which does not detract from the sitter in any way. Others choose an appropriate scene or a sketchily painted backcloth which provides a suitable setting but does not

Below: *Backgrounds are important in determining the mood of a portrait. In these pictures, we see how the color and pattern behind the subject dictate not only the overall effect but also how we perceive the subject; for example, the brown background emphasizes the warm brown tones of the hair and beard.*

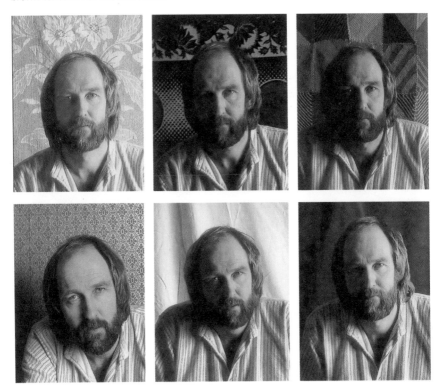

dominate the picture. Some portrait painters consider the background almost as important as the subject itself, reveling in a busy composition filled with minutiae and detail.

The most important thing is to plan the setting carefully as an integral part of the painting, and not to put it in as an afterthought when the rest of the painting is almost finished. Your background should be something you choose, and even if you intend to paint the sitter against a plain wall, the color and tone of the wall should be used to complement the subject. Dark skin, hair, and clothing are generally more effective against a light tone, while fair subjects are more suited to a darker background —but you might well decide to reverse this convention. The choice is yours, but it should really be made in the very early stages of planning the portrait.

A collection of drapes and backcloths is invaluable. If you have these on hand, you can quickly try out the various colors, patterns, and textures, seeing instantly what the possibilities are. A somber, dark background might be best for a formal arrangement, a series of colorful patterns for an informal one. The more alternatives you have, the more creative your composition can be.

Space is essential in most portraits. If your subject is painted in three-dimensional terms, with light and shade to suggest the form, then an illusion of space is already created on the canvas. This is why the background is hardly ever painted as a flat color in realistically painted portraits.

A plain wall will usually be graded from light to dark—an indication that normal light never falls evenly—or the subject's shadow will suggest the space between the figure and the background. If you plan a complicated background, perhaps an interior or a landscape, the problem of creating space becomes less difficult. Familiar objects, such as trees, buildings, and furniture, naturally create spatial relationships, and a three-dimensional environment.

What colors should I use in the background?

If just painting a head and shoulders, it is probably best to keep the background simple. If the head is painted with sufficient intensity and atmosphere it will be enough.

A neutral gray mid-tone used behind a head will enhance its warm coloring, and if the background is graded lighter on the darker side of the head—and darker on the lit side—an illusion of space and depth is soon created. This color device has been popular with many portrait painters since the Renaissance.

What can I include in a more personal background?

Many people like their portraits to reflect something of themselves in the background. Traditional double portraits, set in appropriate surroundings—usually the sitters' house or garden—are known as conversation pieces. Such paintings hold a special fascination, recording not only the people but also their lifestyle and home environment. Here the background should be chosen carefully, so as to give clues about the subjects' personalities. A favorite armchair or shelf of books, or even a kitchen, can provide an interesting and unusual backdrop for a portrait.

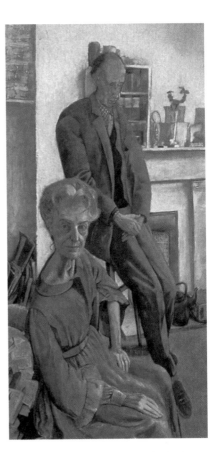

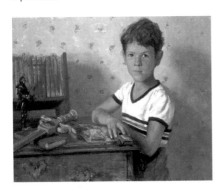

Above: *Jane Bond,* Jeremy *(oil on board). The choice of pose and objects in this painting reflect Jeremy's interests and will serve as a wonderful reminder in later years of the child at this age.*

Above: *Ros Cuthbert,* Cecil and Elizabeth Collins *(oil on canvas). Placing figures in their home environment, surrounded by favorite possessions, makes a personal statement and also allows the possibility of more negative shapes within the painting.*

What is a triangular composition?

Many portraits of the head and shoulders
of a figure form a triangular composition.

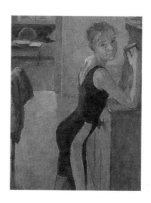

Right: *Juliet Wood,* Emily in Cycling Shorts
*(oil on canvas). Emily's body forms a steep
diagonal as she leans towards the edge
of the picture, leaving half the picture
free for the view through two rooms and
into the garden.* (See also page 26.)

What is a diagonal composition?

Repeating the angles of the figure in the
background shapes can make the
composition stronger.

Verticals and horizontals give stability,
diagonals suggest movement. Furniture,
a window frame perhaps, may provide a
choice and offer inspiration. Symmetry is
best avoided, though this does not
mean you have to avoid a directly
forward-facing pose. It is essential to
create the illusion of space, whether
shallow or deep, and to entice the eye
around and into the painting.

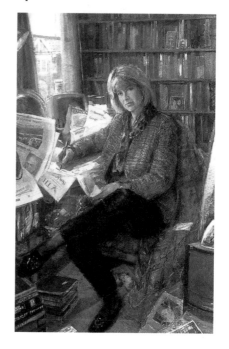

Right: *Barry Atherton,* Julia Somerville
*(pastel and collage). The angular pose
of the subject is echoed in the chaos
of books and papers. Newspapers were
used as collage material and their headlines
preserved in the final portrait.*

What do you mean by light–dark relationships in a painting?

Great contrast between light and dark colors will call for immediate attention in a painting. Colors that have a similar tone tend to visually link together.

In these paintings notice how the artists have used light-dark contrasts to attract attention to some areas and lesser contrast to subdue other elements in the paintings. Try to be aware of light–dark relationships in your composition. For example, if your model is wearing a large, dark hat, this will frame the head and a pale background could be used. But if she is blonde, a mid-toned background will emphasize her face while a very dark color might be overpowering. (*For more about backgrounds see pages 52, 53, and 54.*)

Above: *David Cuthbert,* Laura *(acrylics on paper). Here the artist has emphasized the tonal contrast between the pale face and the dark hair.*

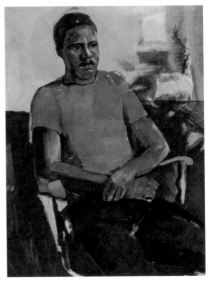

Above: *The immediate contrast is between head and background. The lower part of the painting consists mostly of linked middle and dark tones. A small amount of light behind the figure separates it from the background.*

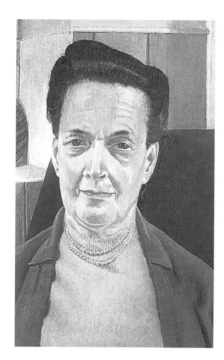

Left: *Jack Seymour,* Mrs. Blackmore *(oil on board).* The soft shine of a pearl can be indicated quite simply. Here, the darkest value is almost in the center of each pearl. Beneath the necklace the woman's sweater reflects upwards creating a lighter, warmer value, while above it the highlight is white.

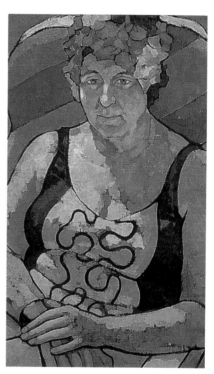

Below: *Ros Cuthbert,* Last of the Snow—detail *(oil on board).* Because of reflected light from the pillow lighting the half tones, the girl's nose has a central panel of shadow running along its length. The highlight next to this shadow shows that the nose projects forward, and is very important since the modeling is otherwise very light.

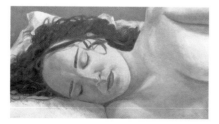

Above: *Robert Maxwell Wood,* The Exercise Swimmer *(oil on canvas).* Here, undulating lines on the swimsuit follow the forms of undulating flesh. The hat adds a humorous touch.

What is the format of the portrait?

The format is the outside shape of your canvas or frame. The format can be vertical, horizontal, or square. Vertical formats tend to command a little more attention even before you paint anything on the canvas. Horizontal formats are more restful on the eye, and square formats are a little more static. You can plan your shapes to paint very successful portraits in any of these formats.

Below: *Against the light background, the angled pose of the model and striped chair, plus the contrasting verticals of the lamp and drape, add drama to this horizontal format.*

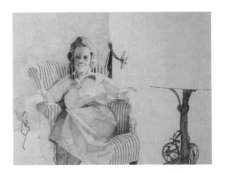

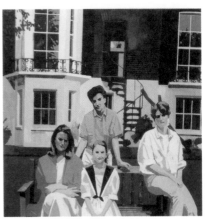

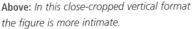

Above: *In this close-cropped vertical format the figure is more intimate.*

Right: *The almost checkerboard pattern of light and dark shapes throughout this square format guarantee that it will be interesting to view and definitely not static. The use of more color in the shapes of the foreground figures separates them from the background.*

What is the "golden section"?

Important elements in a painting can be placed on these vertical and horizontal divisions of the rectangle to help balance the composition.

The idea of drawing as design, which includes the idea of drawing with a brush, involves the ability to consider the image in relation to the shape and format of the surface.

During the Renaissance, compositional organization provided the foundation for all artistic concerns, and the rediscovery of a means of establishing ideal proportions resulted in a general belief in the importance of the "golden section." This term is applied to the aesthetic harmony of proportion produced when a line is divided in such a way that the smaller division relates to the larger just as the larger relates to the whole.

By geometric application, a rectangle can also be constructed in such a way that subdivisions within the rectangle will accord with this harmonious relationship.

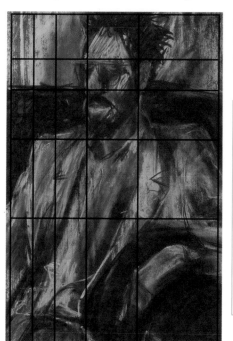

Left: *Notice how many of the main divisions of space and the figure in this drawing fall on or near the proportional lines of the "golden section."*

ARTIST'S TIP

Although some painters have put the theoretical golden section into strict practice, many others have applied it in an intuitive manner. Triangles and pyramids have also been employed as a means of establishing a stable and powerful structure for paintings, one especially evident in religious compositions. With experience, painters have taken more liberties with pictorial organization, and it may not be evident that any one geometric form dominates compositional structure through the centuries.

What is meant by "blocking-in" the composition?

This is the initial stage of a painting when the main forms and composition are laid down in approximate areas of color and tone. Some artists prefer to block in the shadows of the subject in tone before adding color.

Right: *Here, the artist blocks in basic tones and colors, keeping the image fluid, and constantly changing and readjusting the main elements in this early stage.*

What does "placement" of the figure mean?

This refers to the placement of the figure within the composition and is important in all picture making. Direction is also important. The background of a portrait can add a great deal to what the artist is attempting to say about the sitter.

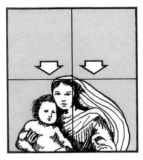

Above: *The figure is below the center-line, bringing the observer's eye into the subject.*

Above: *The downward glance of the figure tends to lead the observer's eye downward too.*

Above: *Background can add information about the sitter.*

What do you mean by an "abstract" pattern in a portrait?

Abstract paintings rely on color and form rather than the realistic or naturalistic portrayal of subject matter. In the painting *Woman in a Black Slip*, below, the artist has worked up to the area of light, painting the darks and the mid-tones so that the highlight areas are established by a process of elimination—

they are where the dark is not. He has "felt" the shapes and volumes of the figure and has created an image which has both bulk and weight. The painting is also a pleasing abstract pattern, the areas of red and black creating interesting patterns against the relatively empty background.

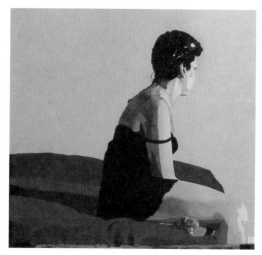

Above: Woman in a Black Slip. *The artist has let the white of the canvas stand for the highlight areas where the most direct light is striking the figure.*

Below: *David Cuthbert,* Tomasin *(acrylic on paper). Tomasin occupies half the space, her contour forming a steep, curving diagonal, while the rest of the picture shows the room. The artist has simplified the door, wall, floor, and furniture with an almost abstract expression of space.*

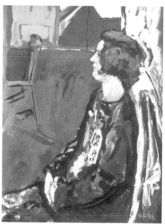

What is "realism"?

The use of realism in painting is an attempt to create an illusion. The artist presents a picture as if it is part of the actual world, as if the viewer is looking through a window onto a scene.

Realism in painting may be described as the representation of the natural world in as generally recognizable a way as possible, using perspective and tone and other painterly devices. As realism became accepted in the West, its aims became confused and this resulted in a common misconception that the sole purpose of painting was to mimic the natural world.

The importance attached to this realism is essentially a Western dilemma. Eastern cultures have always remained aware of the distinction between the visual world and the world of artifice that includes the flat surface of a painting. The Eastern point of view is reinforced in the way that the Western vision of reality, as presented on canvas or paper, has changed over the centuries. This in itself is further proof of the impossibility of an objective portrait. Art is not life; the fascination of painting and drawing is in the revelation of personal visions.

Above: *Ros Cuthbert,* Cecil Collins at the Central School of Art (England) *(oil on canvas). Here, the contrasting qualities of the fabrics (felt, tweed, and leather) are an important part of the painting.*

How do I deal with more than one figure in a portrait composition?

Once you have painted single figures for a while, you may want to try a composition of two or more figures. Arranging figures together is not easy. Many group portraits are dull because they are unimaginatively composed or unconvincing because of poor spatial relationships. It is worth making studies to gain ideas about how we look in groups. These could be "thumbnail" sketches or more complete studies. When you have found a composition you like you can proceed, but remember that

adjustments are even more tricky where more than one figure is involved, so be sure of your composition.

Photography is very useful in group portraiture. In the quiet of the studio, ideas can be tried out without wasting your sitters' time.

A group composition should have a strong sense of pattern and design if it is to hold together. Vary the angles of faces and limbs to help the eye around the picture. A variety of light sources might also add interest.

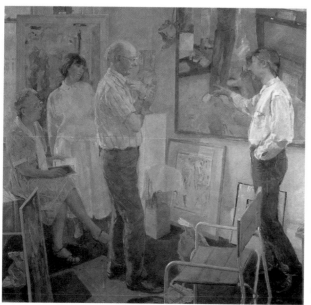

Left: *Linda Atherton, But I Know What I Like (oil on canvas). This portrait was done from life over a period of a year, the sitters coming along when available. The elderly man and seated lady had ten sittings each, the other two had four. At certain stages the sitters had to appear together for the composition and skin tones to be checked. No photographs were used.*

What is meant by "cropping" the image?

Cropping in closely creates interesting negative shapes around the head (*see page 46*). A viewfinder can help you to see more clearly what to include and how the shapes will appear when you crop your subject. You can make one by cutting out two L-shaped pieces of card and fixing them together to make a rectangular hole (*see page 49*). Use paper clips so the hole can be altered. By looking through it at the subject, you can find the best composition—and see what is best left out. Some artists peer through their fingers, but others find this awkward.

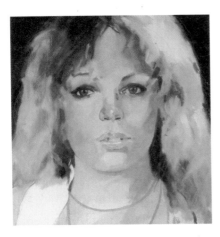

Above: Girl with a Red Necklace. *The artist has cropped the image so that the girl's head fills the picture area.*

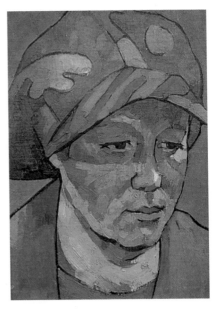

Above: *Robert Maxwell Wood,* Portrait With Shaded Eyes *(oil on canvas). A peaked cap provides a bold contrast to the more broken handling of the face. Its peak casts a broad shadow which provides a color link between hat and face and creates positive and negative shapes in the top of the painting.*

ARTIST'S TIP

Many portraits of head and shoulder figures show one eye of the sitter placed in the vertical center of the canvas.

How can I use the composition to tell a story about the subject?

Some artists use objects to tell a story about their subject. The artist painted the couple below with their glass cabinet full of china cats and a copy in miniature of the family coal wagon. Mr. Trapnell was a coal merchant and his wife used to breed cats and so it seemed natural to include both of these in the painting as part of the couple's story. Such anecdotal details give enjoyment to the viewer as they provide a context for the final portrait.

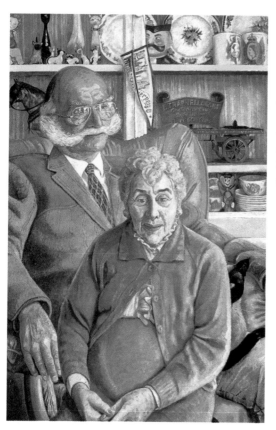

Left: *Ros Cuthbert,* Ray and Moya Trapnell *(oil on canvas). This composition was inspired by a Stanley Spencer portrait of two sisters. Ray and Moya sit on separate seats, one in front of the other, giving a compressed sense of the space between them. The objects in the cabinet behind provide a narrative of the sitters' lives.*

4

SKIN TONES AND COLOR MIXING

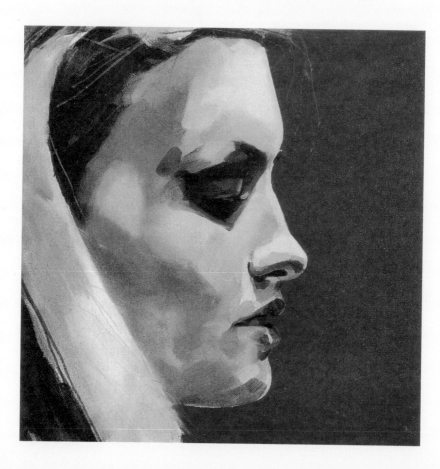

What is a skin tone?

Beginners tend to think there is "a way to do it" when painting skin tone, but this is not really so. All colors are also tone, in the sense that they have a tonal value. Violet, for example, is dark and yellow is pale. The important thing is to practice mixing the colors you see as accurately as possible. Later on you may realize that colors can be manipulated to give certain effects, but the first concern should always be simply to record what is there as faithfully as possible. A "way to do it" reveals itself slowly. This is so much better than being provided with a crutch which may be hard to discard later.

There are very many different skin types, even in the same ethnic group. For example, a "white" person can be pale peachy pink, creamy bluish white, olive-skinned, or even deep red. Asian and African skins are equally varied. Not

only this, but light itself as we have seen can be "warm" or "cool" in color temperature, further complicating the choice of palette.

(*See also pages 33, 34, 36, 37, 38, 39, 40, 75, and 165.*)

Right: *There is no "correct" way to paint flesh tones. In these four portraits we see some of the ways in which different artists tackle the subject and the colors they used.*

Is there a formula for painting skin tones?

Flesh tones are a subtle mix of light and dark and warm and cool. All portrait painters use green or blue, sometimes both, for the elusive cool shadow tones present in all skin types.

There is no easy formula for painting flesh tones. Every artist develops a personal technique, and no two artists approach the subject in the same way. Many Renaissance artists underpainted

all flesh areas in green earth mixed with lead white. The artist Ingres created subtle, highly finished paintings, with the muted cools and warms blended to form realistically smooth flesh. Cézanne, on the other hand, used broken color and strong directional brushstrokes to depict areas of shade and highlight.

How can I simplify painting the skin tones of the face?

For quick color sketches, or paintings in which the figure is small and relatively unimportant, it is sometimes useful to try to see, and then paint, the face into the simplest possible terms without losing its identity or form.

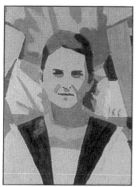
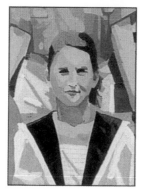

Left: *If we follow the progress of this face, we see how the artist tackled painting simplified skin tones. The shadow areas are established first in a thin mixture of raw umber and ivory black. Light and medium flesh tones are then added to this, each area of tone being represented by one or two simple brushstrokes.*

How can I choose a palette of colors to start with?

Begin with a simple palette setting, or choice of pigments. Why not begin in oils or acrylic with the palette of a great master? Rembrandt used only four—or possibly five—pigments. They were black, white, yellow ocher, and light red (a red-brown pigment), with the possible addition of raw umber. A "white" skin painted in north-light conditions can be reproduced with just these few colors. So the first thing is to become familiar with this palette setting by painting several portraits with it. This simple palette and a cool, steady north light will introduce you gently to the subtleties of interpreting colors and tone values in a human face.

Left: *For this portrait, the artist worked in a bright color key, relating a set of strong, bright tones to each other. She lay them separately on the canvas, placing pure colors side by side. This bold approach created an intense appearance. You can see more examples of palettes used by other artists in the step-by-step demonstrations in Chapters 7, 8, and 9.*

Now I have the colors; how do I start to mix the skin tones?

Having first drawn in the contours, you will need to mix a flesh tint and a half tone. To find the former, look at the color next to the highlight. It could be mixed using a balance of white, light red, and ocher. The half tone is the color between the flesh tint and the deepest shadow areas—in the nostril perhaps—and being darker and cooler than the flesh tint will need black and possibly a little more yellow ocher and light red. It may need to be greenish compared with the flesh tint; black works well here.

Darks such as nostrils and shadows in ears may need warming up with a little light red, and cheeks, if they are pink, may need a touch of cadmium scarlet or crimson alizarin. Highlights, if you are working in north light, will be bluish.

Lighten the flesh tint with white to the required tonal value and cool it with a tiny touch of black, cerulean, or cobalt blue. A pale gray, mixed with white and black, should read as bluish if surrounded by warm flesh colors.

Above: *Using a small sable brush and warm and cool flesh tones, the artist begins to model the face of the figure working from one point outwards. Moving downwards, larger areas of highlights are blocked in and then blended into surrounding areas with a dry, clean brush.*

Above: *The artist blocks in the flesh tones. The bright pink around the eye reflects the pink and white used for the sitter's blouse.*

Are there other options for palette colors to use for skin tones?

A good basic range of colors for a portrait painter to start with would possibly be white, black, chromium oxide, cerulean blue, ultramarine blue, alizarin crimson, light red, cadmium red, raw umber, burnt sienna, raw sienna, cadmium yellow, and yellow ocher.

Many painters work with far fewer colors, and you may eventually find that some of these are superfluous. Above all, do not be frightened of experimenting and introducing new variations to your palette.

As you will see from the way the artists in this book work, there is no single "correct" approach to painting or drawing flesh. You will also find some different color palette options from other artists in the final chapter of this book (*see page 210*).

Cadmium red medium *is close to primary red. Cadmium light and dark are versions of the same color. They are opaque and mix well with yellow to make orange—essential for bright, warm flesh tones. They cannot be mixed with blue to make violet and purple.*

Alizarin *(phthalocyanine crimson) is a cool, bluish red often used with ultramarine blue to mix cool, purplish flesh shadows. It also mixes with white to make basic pink.*

Rose *(naphthol crimson) is a vivid pinkish red and a useful addition to the portrait painter's palette. Versions are produced under different names (Rowney Rose is one oil-paint example). Rose, madder, geranium, and magenta are all good.*

Ultramarine blue *is regarded as the "primary" blue. It is used by nearly all artists. It can be mixed with crimson and pink reds to make purples and violets, and is often used in cooler skin tones.*

Cerulean blue *is a gentle, sky blue used for its opacity and distinctive color.*

Raw umber *is often used instead of black to tone down other colors. It is used by the majority of artists. Its yellow-brown pigment has relatively poor tinting power.*

Cadmium yellow *is a standard, primary color used to make strong greens and oranges when mixed with blue and red respectively. It is strong and opaque and comes in light, medium, and dark tones.*

Raw sienna *is a fairly opaque, sandy color. It is a mixture of ocher, orange, and brown. When mixed with greens, blues, and purples, it produces a range of rich earth tones suitable for many subjects.*

Yellow ocher *(yellow oxide) is used by the majority of portrait painters. This dull, dark yellow is fairly opaque and almost essential for making white flesh tones, when it is often mixed with burnt sienna, white, and a little blue.*

Titanium white *is an opaque white with good covering power. Only a small amount of titanium white is necessary to lighten a color, thus preserving the transparency of the color.*

Chromium oxide *is a dull gray-green. It is opaque and occasionally used to underpaint flesh tones.*

Ivory black *is a popular, dense black which should be used sparingly for mixing. Many artists use no black at all, preferring to darken color with an alternative dark pigment, such as raw umber.*

What colors would I use for a person with black skin tones?

A "black" person may be anything from a warm coffee color to very dark, almost black. Look for the warmth in the flesh tint. Having mixed a brown with, say, raw sienna, Venetian red, and white, check that you do not need to warm it further, especially on the cheeks.

A bluish sheen is often present on very dark skins—an exciting quality to paint. Lips are always warmer than the overall flesh tint—add a touch of crimson to them—but do not overdo it unless the subject of your painting is wearing lipstick. (*See also pages 165 and 208.*)

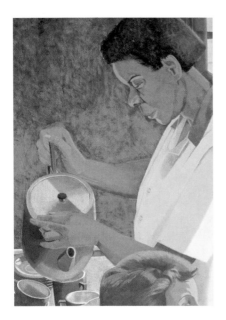

Above: *Ivy Smith,* Lunchtime on Reynolds Ward—detail of Celestine *(oil on canvas). The palette setting for Celestine was yellow ocher and rose madder. She was painted from black and white drawings.*

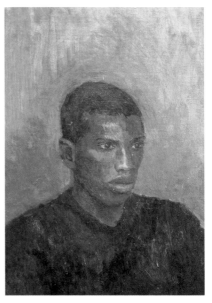

Above: *Helen Elwes,* Bruce—detail *(oil on canvas). Bruce's lower lip is lit by a broad highlight while his upper lip is more in shadow, except around the top edge where highlighting is visible.*

Should I use different colors for painting children?

If painting a child, the palette might need to be capable of producing delicate, clean colors. Try cadmium orange and white as a flesh tint, or cadmium scarlet and lemon yellow (or cadmium yellow pale which is a more opaque pigment) with white, subdued with cobalt blue for the half tone. The colors should be mixed with the utmost care and tone values not over darkened, the blending done lovingly to produce the delicate movements from light to shade and to preserve the luminous quality of a child's flesh.

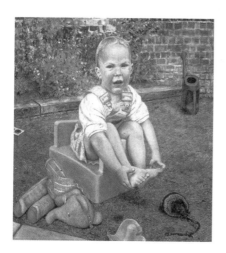

Above: *Ros Cuthbert,* Hedda *(oil on canvas). This two-year-old girl was painted from photographs backed up with sketches. The palette setting was titanium white, yellow ocher, raw sienna, and raw umber, with touches of cadmium red, rose madder, and cobalt blue.*

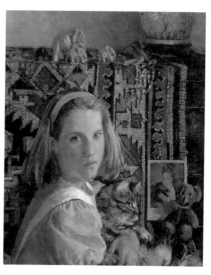

Above: *Jane Bond,* Laura *(oil on canvas). The child and her cat are softly lit, probably by natural light coming through a window. They are painted in brighter, lighter tints than the background. In this way the artist avoids overpowering her sitter's young face with the heavily patterned carpet.*

What colors can be used for a face which has been outdoors in all weathers?

A face which has been outdoors in all weathers may be reddish or even purplish, requiring cadmium red or carmine, and possibly ultramarine in the flesh tint.

A sun-bronzed skin will need an addition of raw sienna and/or cadmium scarlet, or possibly a cooler red such as cadmium red deep, which can be further cooled for the half tones with cobalt blue. Remember that shadows are generally cooler in color than the flesh tint, and the highlight takes on the colors of the light source.

Right: *Peter Coate,* The artist's father—detail *(oil on board). Peter worked from life on a white ground in opaque paint applied in separate strokes with little or no blending of the wet paint. The drawing was restated with a red brown, probably burnt sienna.*

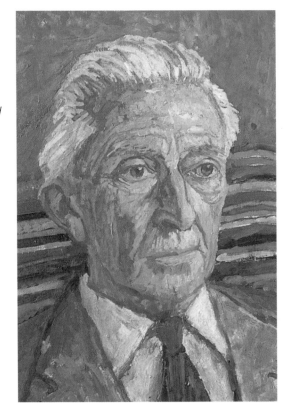

What is local color?

Local color is the actual color of the surface of an object without modification by light, shade, or distance. It is evident not only in skin tones, but every subject and object in the painting.

The local color of a subject's face usually varies very little, though the tonal differences created by lighting can be enormous, ranging not only from light to dark, but also from warm to cool. Shadows tend to be cool; illuminated areas are generally warmer.

Artists often prefer to mix an approximate range of these visible tones at the outset, adding to these where necessary, instead of trying to mix each new tone separately as the need arises.

The planes of the face are rounded, subtle, and undefined, each area of tone merging into the next in an almost indiscernible way. To mix every tone as you come to it is to make a difficult task into an almost impossible one.

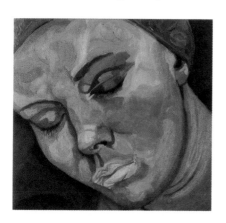

Above: *The flesh tones in this painting are all mixed from yellow ocher, alizarin crimson, titanium white, cadmium red, violet, terre verte, ultramarine, cobalt blue, cerulean blue, and Naples yellow.*

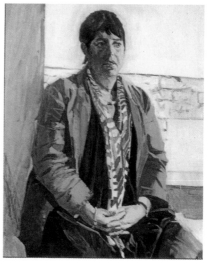

Above: *The local color in the jacket is red, but in the light areas it appears pink and in the shadows a purplish color. In the dress the green is washed out in the light areas and becomes almost black in the darker areas.*

What does a color "key" mean?

Some artists choose a low color key, working from a range of subdued hues. Others prefer brighter colors, or a high color key. The choice is a personal one, the important thing being how the colors relate to each other in the picture.

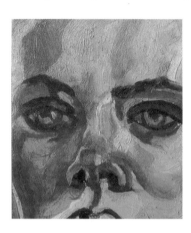

Left: Here the artist uses comparatively bright colors. The initial blocking-in is done in fairly vivid tones—the blues, reds, and greens being quite discernible in the overall image. This blocking-in sets the "key" for the rest of the painting, and the subtle tones and planes of the face are well observed in a range of distinct, clear colors.

What do you mean by warm and cool skin tones?

The human skin is composed of many shades of varying warm and light tones. Generally, in white skins, the shadows have overtones of blue, green, or purple, while the lighter areas are mainly yellows, pinks, and oranges.

However, the division is not absolute. Often there are warmish tones in the shadow areas and comparatively cool tones in the lighter areas and highlights. Much depends on the subject's skin color and the lighting.

Right: A close-up view of this face shows how the artist has carefully observed the changing color temperatures across the surface of the skin, portraying these in accurate and clearly defined planes.

What is broken color?

Broken color refers to paint applied in its pure state rather than being mixed. This stiff paint is usually applied by dragging the brush across the surface, allowing the layers of color underneath to show through.

Above: *In these details, the artist has not attempted a high degree of finish, but has left the paint as rough patches of color. From a distance these merge, but the broken texture animates the surface.*

Below: *David Cuthbert,* English Odalisque *(acrylic on paper). The largest and most striking areas of contrast are in the figure. The remainder is broken up by smaller brushmarks denoting patterned fabrics. Bright green and blue provide relief from the rich reds and purples.*

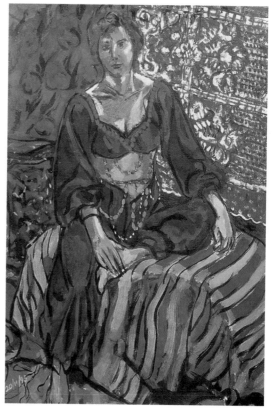

What are complementary colors?

Complementary colors appear opposite each other in the color circle. Hence, purple is complementary to yellow, green to red, and orange to blue.

Our eyes are designed to seek a balance of complementary colors. This is not the place for a lesson on complementary color harmonies, which can be looked up elsewhere. But if you stare fixedly at a large, bright patch of red and then move your gaze to a white surface, what you see is a green after-image. In subtle ways, this dynamic interaction is going on all the time without our being aware of it. But as your "painter's eye" develops, you will begin to notice that if there is a large area of, say, red behind your sitter or if he/she is wearing red or bright pink, the skin colors may appear greenish.

Similarly, a surfeit of bright violet will give the skin a yellowish appearance, while yellow makes pale skins look rather sallow or gray. This can be used to advantage, for instance, blues, greens, and cool grays enhance the warm appearance of flesh. In short, no color exists by itself but is influenced by what is adjacent to it. It is this interactive quality which is a source of such endless fascination for artists.

> **ARTIST'S TIP**
>
> Complementary colors—any color that lies directly opposite another color on the color wheel—will make each other "sing," or complement each other when they are placed side by side, but when mixed together, they will gray each other down or neutralize each other.

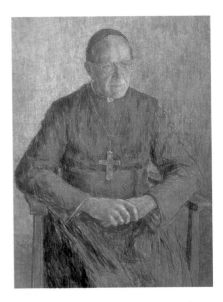

Above: *Helen Elwes,* The Reverend Derek Warlock—Archbishop of Liverpool *(England) (oil on gesso). Complementary colors make up the background of this painting.*

What is meant by an *imprimatura*?

This involves rubbing or brushing a very thin layer of transparent color over the white ground. Traditionally raw umber, burnt umber, or terre verte were used. You can see the logic of it if you look at the back of your hand. Dull green beneath translucent flesh tint produces the appearance of veins, helps cool down shadow areas, and enhances the warm tints of the flesh adding to the luminosity of the skin tones. The *imprimatura* could also be made in acrylic as a basis for a subsequent oil painting.

It is also a good idea to use a palette for mixing the colors that are a similar color to the one that you have applied to the canvas. You can achieve this easily by placing a piece of colored paper to match the underpainting under a rectangular sheet of glass. You can mix your paints on the glass surface and the color relationships that will occur on the painting can be seen more easily. The colored paper can be changed to match the *imprimatura* of other paintings.

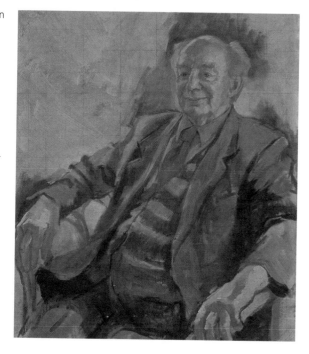

Right: *Juliet Wood,* Stephen Brown—in progress *(oil on canvas).* The artist worked on a homemade "half-oil" ground using equal amounts of titanium white and calcium carbonate (chalk) mixed with a weak rabbit skin glue (available as a powder from art suppliers). To this she added cold-pressed linseed oil. The amount of oil determines the absorbency of the ground and also its drying time.

What is *alla prima*?

Alla prima is direct painting in which the picture is completed in one session without underpainting or underdrawing. It can also be used as the final painted oil color layer over an acrylic underpainted—*imprimatura*—layer (*see page 81*).

Once the underpainting is dry, work with thin layers of transparent and translucent paint to develop the shadow areas. The flesh tints can be kept thin in places to make use of the *imprimatura* and applied more thickly to cover it where lighter tints are needed. This will familiarize you with the roles of transparency and opacity in building up an illusion of solid form.

In spite of careful underpainting, you may find the likeness disappearing as you paint the *alla prima* layer. The paint hides the underdrawing, and contours and volumes imperceptibly shift as you work. If this happens, try moving your eyes at speed between your sitter and portrait to see where the shifts have occurred. Looking at your painting in a mirror may help, or squinting at it through half-closed eyes. This cuts out inessential details and could disclose the underlying problem. If all else fails, return to careful measuring. Portrait painting is always the dialogue between correction and development.

The techniques used for this portrait demonstrate an oil painting method which is essentially direct and spontaneous. As the painting was completed in only two sittings, the paint had no time to dry. For this reason the artist would occasionally blot the surface with a rag, or sheet of paper, to lift excess moisture.

Work rapidly with stiff bristle brushes to block-in the overall impression of the image, using the brushmarks to indicate the structure and texture of the forms. Small sable brushes are more suitable for adding fine points of detail.

Experiment with color mixes on a separate piece of paper or board to find the right tones for subtle flesh colors and shadows. Build up the shadows and highlights in the face and hair using small dabbing strokes to blend the colors.

A color photograph rather than a live subject was used for the painting, but the information supplied was used only for the groundwork of the painting and the end result is not a straightforward copy. Photographs tend to flatten subtleties of tone and color, so it is necessary to add to the image by strengthening or even exaggerating certain elements. In this example, the background color and patterns in the clothes were altered as the painting progressed.

1 Use brown and blue to make a neutral color and outline the shape of the face and features. Start to define warm and cool color areas with flesh tones, dark yellow, and brown. Strengthen the background.

2 Spread the paint in the background and lighten highlight areas with a dry rag. Use dark colors and flesh tones in the face, using a No3 bristle brush.

3 Use a No5 sable brush to apply highlights of light yellow and pink. Paint the jacket with a thick layer of light color.

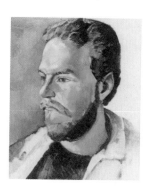

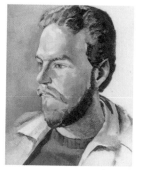

ARTIST'S TIP

Keep correcting to a minimum in an *alla prima* portrait and the surface of the painting will have a lively, spontaneous appearance with fresh, broken color quality.

4 Lighten the color of the background, at the same time correcting the outlines.

5 Using the background color as a guide, make adjustments to the tone and color over the entire image, blending the paint with light strokes of the brush.

What is optical mixing?

Optical mixing occurs when color is mixed in the painting rather than on the palette. For example, using dabs of red and yellow to give the illusion of orange rather than applying a pre-mixed orange.

Pastel colors can be blended by rubbing them together, usually with cloth, tissue, or the fingers. Or—as the artist has done below—they can be blended optically, to mix in the eye of the viewer rather than being blended together on the support. Here the artist has relied heavily on drawing, on the linear marks made by the pastels, to build up the structure of the face. She mixes colors by laying thin meshes of pure pastel, one on top of the other, to create new hues. (*See also page 191.*)

Above: *The rich greens in the beard and mustache are the result of dense layers of blue and yellow lines; many of the mauve and purple tones come from blue and pink; and the vivid oranges of the lips and skin tones are "mixed" from primary red and yellow.*

What is meant by glazing?

Glazing is a method of building up color in thin layers, or applying a transparent layer over a solid one so that the color of the first is slightly changed. The method produces a luminous finish which makes it particularly appropriate for painting the subtle, translucent tones of the skin, but it is a relatively slow process, because each layer must be allowed to dry.

The steps below illustrate how oil glazes can be applied. The layer to be worked over is pale in color so that light will reflect off it through the successive layers of paint.

1 Brush on thin brown paint so that the dry underpainting still shows through.

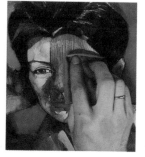

2 Use a cloth to spread the paint evenly and to wipe off the excess.

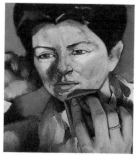

3 Leave the highlights around the eye white.

1 An alternative technique is to overpaint thicker white highlights onto a brown glaze.

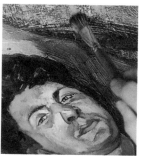

2 Sandpaper the background, then paint a blue-gray glaze for a changed effect.

ARTIST'S TIP

Do not use turpentine alone to thin oil paints for glazing, and never use turpentine substitute. Turpentine mixed with linseed oil is not ideal as the oil tends to move after it has been laid. It is better to use a glazing medium, such as the alkyd medium called Liquin. Increase the oil or glazing-medium content with each new layer.

How important are the brushstrokes in painting the skin?

Brushstrokes can be left as part of the painting process to add vitality, movement, and a feeling of form in the face and figure. They are generally applied following the direction of the form. In this way, they can add texture and a sculptural quality to the painting.

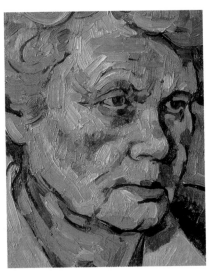

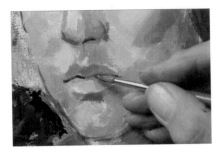

Above: *The artist applies color in short, thick strokes, frequently defining the outline and linear features in a darker color. Patches of white canvas primer are allowed to show through between the dense paint marks.*

Above: *Robert Maxwell-Wood,* Woman in Black and White *(oil on canvas). The brush strokes follow the direction of the forms. The thick paint suggests sculptural solidity.*

How can I make a quick color study for a portrait?

Many artists make elaborate sketches. Some even produce color sketches which are almost indistinguishable from the finished painting, differing only in the amount of detail and finish. These are done relatively quickly, sometimes when the subject is too busy to give lengthy sittings. Often a painter can produce a highly finished portrait in this way. A quick sketch is often more successful in capturing the character of a subject than a carefully worked painting.

The loose, vibrant colors of pastels are particularly suited for quick sketches using a vigorous style, as shape and texture can be shown through the activity of the color rather than the meticulous delineation of the forms.

Gouache is a convenient medium for doing quick color studies. It is cleaner to work with than oils and is also more opaque and matte than watercolors or acrylics. The colors are clear and intense. When mixed with white, they form a wide range of bright pastel tints suitable for the skin tones in a portrait. Because the paint is opaque, you can work light over dark or vice versa, adjusting the tonal scale of the painting at any stage. The paint is reasonably stable when dry and thin washes of color can be laid over without damaging previous layers.

The fluidity of water-based paints such as gouache means that they are ideally suited for making either color studies, in preparation for larger oil paintings, or quick, complete pictures when time is limited. This type of paint is usually regarded, however, as better suited to landscape subjects than faces, and some experimentation will be necessary when attempting to render the solidity of the human figure and the precise values of skin tones. (*See also page 184.*)

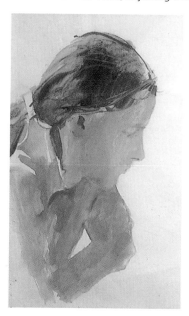

Above: *A quick watercolor sketch.*

Above: *The artist drew vigorously with strong color, developing the tones and background texture and highlighting the face.*

Can you explain what the tonal value of color is and why it is important?

Carefully observing the tones of the colors in the skin in relation to each other will help you in mixing your colors.

Every color has a tonal value. If you can imagine how a color would look in a black and white photograph, you are close to understanding its tonal value. Yellow, for instance, photographs as a light gray and has a high tonal value; dark red or blue reproduces as dark gray and has a low or dark tonal value. The tonal, or achromatic, scale ranges from black to white, and every color has a gray equivalent somewhere between those two extremes. It is important to understand how tone works because it affects the way you use color, and even

the most brightly colored composition can look flat if it lacks tonal contrast.

Many artists make a "tonal" drawing of their subject before starting work, to establish the light and dark areas. This can be done in pencil, charcoal, or white paint used with black or one other color. Good lighting can also dictate the tonal interest in a portrait because it creates contrasting planes of light and shade across the subject's face and elsewhere in the composition. A background that is lighter or darker than the subject's hair or clothing can often help to vary the tonal pattern of a portrait and it is worthwhile experimenting with different combinations.

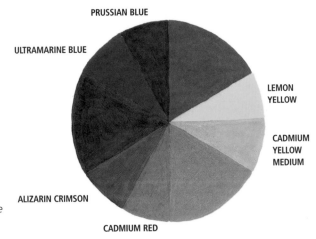

PRUSSIAN BLUE

ULTRAMARINE BLUE

LEMON YELLOW

CADMIUM YELLOW MEDIUM

ALIZARIN CRIMSON

CADMIUM RED

Right: *The tonal scale runs from black to white, and every color has a tonal equivalent somewhere on that scale.*

How can I make skin tones with colored pencil?

Depth and areas of dark tone can be created by hatching and cross-hatching using colored pencil. Apply the pencil in neat, directional strokes (hatching), and build up the tone with overlaid strokes in the opposite direction (cross-hatching). Keep the pencils well sharpened and apply each layer systematically to give yourself maximum control over the texture and depth of tone.

Left: *Here the artist is using several layers of black to build up the deep shadows and recessed shapes of the subject's hair.*

Are there any other ways to use colored pencils for skin tones?

Like brush strokes in paint, pencils can also be used directionally to form the shapes of the face and features. The direction of the pencil strokes can play an important part in describing form. Because pencil is essentially a linear medium, it can be difficult and time-consuming to suggest large forms through light and shade.

Right: *The artist has used the direction of the strokes to help indicate form.*

What colors can I use for a portrait in watercolor?

A watercolor sketch may result in an interesting finished picture, or may be used as a reference for a larger work.

In the picture below, the effect is sketchy and shows a lively impression of the general form of the face and figure, lightly modeled with color and tone.

The artist worked on stretched cartridge paper with a palette of black, burnt sienna, burnt umber, cobalt blue, gamboge yellow, scarlet lake, and ultramarine blue.

For more examples of colors to use in watercolor portraits, see page 184.

ARTIST'S TIP

A basic palette of colors to use for light skin tones in watercolor could be cadmium red or cadmium red light, cadmium yellow light, raw sienna, and cerulean blue.

For darker skin tones, a basic palette of colors to use could be ultramarine blue, alizarin crimson, and raw sienna. To make lighter tonal values in watercolor you will add more water to the paint to allow the white of the paper to show through the paint layer.

Right: *The color is strengthened over the whole image, developing the structure of the forms. Keep the paint fluid and allow the colors to merge on the surface. In this way, the gently rounded planes of the face, fabric, and hair will emerge as natural forms. The face is modeled with heavy patches of red and brown—the brown is mixed from scarlet, raw umber, and burnt sienna—and used to draw in the detail around the eyes with the point of the brush.*

How can I paint or draw skin tones with pastel?

Solid areas of tone and color can be built up using short, closely-packed pastel strokes. This is especially necessary when using darkly tinted paper, because it prevents the paper color from showing through the lighter tones and breaking up and weakening the final image. (*See pages 192 and 193*.)

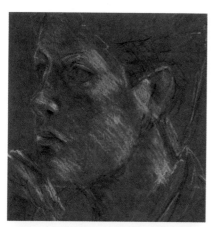

Left: *Here, the artist uses the pastels in even, diagonally parallel strokes, allowing greater control over the density of both the tone and the color. (*See also page 35.*)*

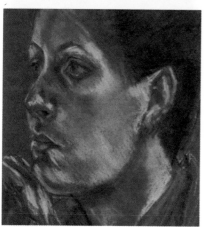

Left: *The flexibility of pastel allows it to be used to depict both line and tone. The artist has combined the two techniques.*

ARTIST'S TIP

Skin tones can also be achieved in pastel by breaking the sticks into short lengths (about ¾ in/2 cm) and using them on the side to make wide individual "brushstrokes". These strokes can be painted in the correct tone and color following the direction of the form much in the same way as in an oil painting.

5

FACIAL FEATURES AND HAIR

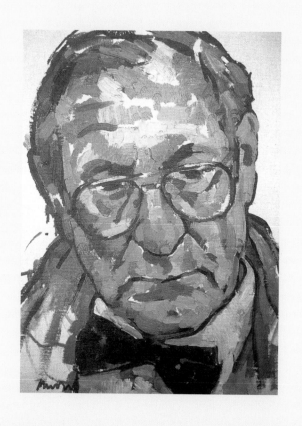

How can I paint eyes so that they look alive?

The most important thing when looking at the sitter is to notice the play of light on the eye. Light crossing the eye from the side will enter the iris, illuminating its opposite side. The light and shade in an iris is the other way around from the "white," rather as it is inside and outside of a pitcher. Thus, the highlight will appear over the darker side of the iris, on the side nearest the light source. If you get this right, the eye will appear transparent and alive.

How does the shape of the eye change when the head is not viewed straight on?

The eye is close to being a perfect sphere. Most of it is hidden inside the eye socket with only a small section visible—perhaps less than an eighth of the whole surface area. The iris bulges forward from the white of the eye and is transparent. The eyelids are formed from a slit in the skin and the thickness of the epidermis is visible on the lower lid between eyeball and eyelashes. The curves of upper and lower lid do not exactly mirror one another; usually the lower lid is a flatter curve. The upper lid normally rests over the top part of the iris, which is detectable beneath it as the eyelid molds itself around it. If the eye moves from left to right, this bulge changes the contour of the upper lid. The upper lid also has a crease above it formed between eye socket and eyeball. This crease does not run parallel to the edge of the upper lid but curves more deeply, arching away from the eye toward its center. In a young person this curve is pure, but as the skin loosens with age, it alters and can fold down over the upper lid. Study the pure curves of a child's eyelids and see how they relate. Ask your model to look up, look down, and look right first and then left so you can draw the differences. Then do the same, working from an adult.

In the three-quarter view, the curves of the eyelids appear compressed; in the profile view the difficulty is to suggest that the eye is not merely a flat triangle but that its forms are moving steeply away from you. Look for every nuance of a curve of the lids, and notice the eye is set back behind the eyelids by the thickness of the epidermis. Also, as the iris is circular, in the three-quarter and profile views it becomes elliptical. (*See also pages 11 and 16.*)

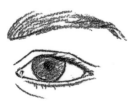 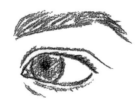 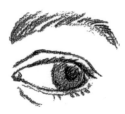

Above: *An eye seen (left) in full face, (center) in three-quarter view, and (right) in profile.*

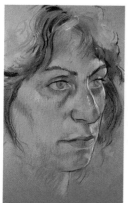

Left: *Robert Maxwell Wood,* Head of Nicky *(charcoal and pastel).*
A three-quarter view. Note the steeper perspective on the far iris and pupil.

Left: *Robert Maxwell Wood,* Girl's profile *(black chalk). Here we have even less than a true profile. Note how, with a few marks, the artist has linked the eye to the cheek, nose, and eye socket.*

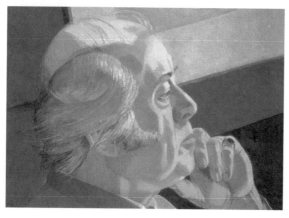

Left: *Ivy Smith,* Portrait of Sir Richard and Sir David Attenborough—detail *(oil on canvas). In this profile we look slightly down at the sitter. The lower eyelid thus appears to curve steeply while the upper is almost a straight line. The line of the eye socket is detectable in the fleshy forms around the eye.*

What color are the whites of the eyes?

The whites of the eyes are not as white as their name: In a child they might be pale blue, in an older person pink-tinged. They are rarely lighter than the lightest tone on the face. The whites vary more than is commonly supposed, from very bright to extremely dark. There is a difference in tone between the eye on the shady side of the head and that on the illuminated side. The eyelid covers the top part of the iris. Allowing the white to show around the iris creates an abnormal stare.

Right: *It is a common mistake to overwork the eyes. They should always be looked at in the context of the rest of the face. Here, the artist adds touches of color to the whites of the eye.*

How can I paint the eyes so that they fit in the face?

It is easy to overstress the subtle lines of an eye, so don't make everything too heavy at first. Look for the warmth in crease lines and the pink in the inner corner—the tear ducts. Some artists successfully exaggerate the redness of the tear duct to give heightened contrast and to suggest life and warmth.

Right: *It is tempting to pay too much attention to the eyes, especially in self-portraits. This often results in a strange, fixed gaze. The eyes should be described in no greater detail than any other part. Here the artist uses broad, simple strokes of paint.*

How can I paint the iris and the eyelashes?

The iris has a ring of darker color around its circumference. The pupil is dark like the entrance to a cave, which is what it is in miniature. If black seems too "hard," try lightening it to a blue-black or even a warm, slightly reddish black. Eyelashes should be painted with delicacy so that they don't appear false. It may be better, depending on your style, to avoid depicting individual lashes. Study the work of the professionals to see how they cope with such details.

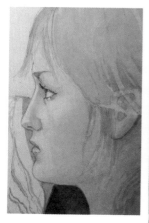

Above: *In a profile view the iris and pupil will be a narrow ellipse.*

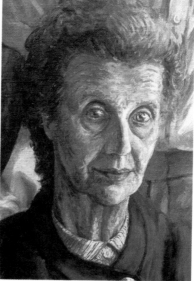

Left: *Ros Cuthbert,* Portrait of Group Captain Cheshire and Lady Ryder— detail *(oil on canvas). In this portrait, the light is clearly visible entering from the side and shining on the side of the iris furthest from the light source.*

Left: *For finer areas, such as the shadows under the eyes and around the mouth, the artist in this example used a colored pencil. Instead of using neutral tones, they chose cool blues and greens to contrast with the warmly tinted paper.*

Are both eyes always painted the same?

The left eye does not always exactly mirror the right. It might vary in size, shape or angle—or all three! You should also study the color and texture of the skin around the eyes, which needs to be properly seated in its socket and related to brow, cheek, and nose to appear convincing.

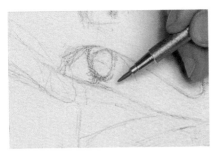

Above: *The artist uses a clutch pencil to draw the outline of the eyes. This is done carefully, with special attention to the structure of the eye and the underlying eyeball.*

Above: *Working from light to dark, the artist uses a fine brush to paint the narrow shadow thrown by the eyelid across the eyeball.*

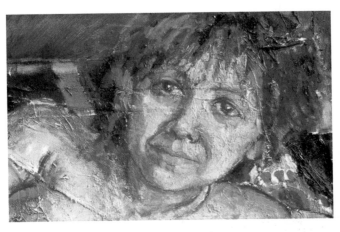

Above: *Jane Percival,* Tina *(oil on canvas). Note the asymmetry of both eyes and eyebrows in this portrait. The woman is staring, and more white is visible below the iris than usual.*

How can I make the glasses on my model fit in with the face?

Beginners often make the mistake of trying to draw a head first and then putting the glasses on it afterwards. They think of the glasses as being separate, which of course they are in practical terms. But to a painter, they are as much a part of the face as the nose. Therefore, include them along with the eyes and nose among your first marks, and integrate them properly into the sculptural unity of the head.

Spectacle frames can be flamboyant or eccentric in design, or very subtle. Keep a sharp eye on any design quirks; for example, the lower rim of the glasses may be narrower than the upper, and curves may vary from one side to the other. In a three-quarter view you will notice that the frames are not quite flat but follow the curve of the head—so the far lens will be more foreshortened than the near one.

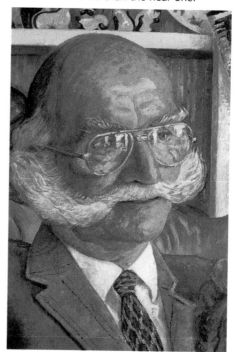

Right: *Ros Cuthbert,* Ray Trapnell—detail *(oil on canvas). The reflections in the subject's spectacles were very strong and the artist had to be careful that his eyes did not become lost behind them.*

Should I paint all the shadows, shapes, and reflections that I see in the glasses?

Sometimes the eyes are only visible as shadow shapes behind the glasses. In this case, you must paint or draw exactly what you see and not try to invent eyes behind the glasses. Spectacles do present a considerable additional challenge, not least because they make the eyes more difficult to see, and in extreme cases, greatly enlarge or reduce their apparent size. The best advice is to look carefully and paint only what you can see. Beware of invention, that is, what you "think" you see, rather than what you see, and be on the lookout for the effects of foreshortening on the frames. If the eyes are too hidden in shadow, introduce extra lighting at a lowish angle. But it may also be that the lenses focus extra light toward the eye. Frames will cast shadows and lenses contain reflections. Both shadows and reflections are an inevitable part of the effect and should be accepted and enjoyed —not "removed."

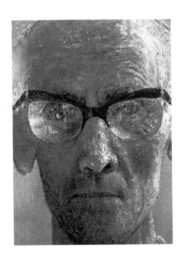

Above: *Ros Cuthbert,* The Reverend Alan Grange—detail *(oil on canvas). The heavy frames of these glasses created shadow, but they also focused extra light onto the subject's face—a tricky combination.*

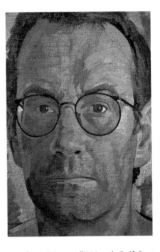

Above: *Robert Maxwell Wood,* Self-Portrait *(oil on canvas). The spectacles are tinted green, transforming the flesh tints. The black frames are carefully drawn, contrasting with painterly handling elsewhere.*

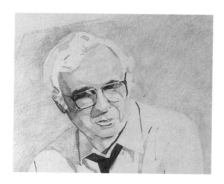

Above: *Notice how the artist has drawn the glasses with a variety of tones—light through dark—and used lost and found edges on the outlines to add interest and dimension.*

Is there a general rule for painting mouths?

Always place the mouth in the context of the entire lower part of the face. As we have already seen, the muscles around the lips raise the whole mouth off the surface of the face. The shape of these muscles can be seen as distinct areas of light and shade, so do not be tempted to portray the mouth and lips as flat shapes. The mouth in this portrait (right) is built up from three basic skin tones—light, medium, and dark. These are mixed from white, cadmium red, yellow ocher, cadmium orange, and cobalt blue, the amount of white determining the actual tone. The artist starts by filling a middle tone, adding the highlights and, finally, the dark shadows. This method of working depends on accurate drawing for its success. Another artist might take a completely different approach, possibly starting with the broad form of the mouth, and then developing this to create the lips, with the highlights being added last. (*See also page 17.*)

Above: *The most important thing to remember is that the mouth is not a flat shape, and that the lips and the face around the mouth have distinct form and volume.*

What do I need to know about the structure of the mouth?

The epidermis around the mouth is quite thick and woven with muscles, giving it mobility and expression. A ring of muscle around the mouth enables us to purse our lips or pout, and radiating muscles help us smile, laugh, grimace, and so on. A full-lipped person is said to be generous, while thin lips suggest meanness or cruelty. This is not necessarily the case, but it does show how important the lips are to us in reading someone's character and intentions. Some think lips have even more expressive power than the eyes, certainly for the play of subtle and momentary emotions. Perhaps this explains why they are so difficult to paint.

Let's look at their structure. To begin with, they are not on a flat surface but follow the curve of teeth and jaws. This is the reason for the steep recession of the mouth in a three-quarter view. In the profile view, the depth of that curve allows us to see the lips sideways on—if there were no curve and the lips rested on a flat surface, we would not see them at all in a profile view.

The lips themselves are narrow at the corners and broaden out in the center as they curve forward from the mouth opening. The lower lip usually bulges slightly and the top lip forms the "cupid's bow" shape as it rises from each corner toward the center, where it dips a little to accommodate the small groove joining it from the base of the nose. In the middle, the upper lip swells forward slightly. The lips do not come together in a straight line—again the "cupid's bow" is visible in the give and take between them. Even in very straight, thin lips these curves are almost always detectable to some degree. When drawing lips, first look for the position of this center line (which has more tonal weight than the others); and when painting, make nothing too hard or the lips will look stuck on.

Left: *Three views of the same mouth seen (left) in full face, (center) in three-quarter view, and (right) in profile.*

What is the difference between painting the mouth in a young face and an old face?

In the profile view, the lips spring forward from chin and nose. Either side of the mouth is a crease line curving down and around from the nostrils. In children, this will only be visible as a change in direction of the volumes of the cheek and mouth area, but in an elderly person you will notice a deep crease. The trickiest part to paint is the corners, which in a child disappear flawlessly into the surrounding flesh with the merest indication of a shadow. With age, this can deepen and form a small crease which should be painted with great delicacy so as not to spoil the likeness or give too somber an expression. Also with age, lips often become thinner and flesh sags. (*See also page 12.*)

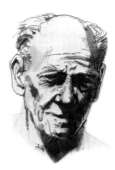

Above: *This octogenarian man has a wrinkled, furrowed face. There is little fat tissue under the skin so the bones and muscles are easy to distinguish. The aging process produces lovely qualities in a face, which are often more fun—and less tricky— to paint than a flawless complexion.*

What color are teeth?

Do not make the teeth too white. They are normally a dark ivory or sometimes even quite gray or yellowish. Notice the effects of shadow on teeth: this is very important if they are to appear realistically behind the lips.

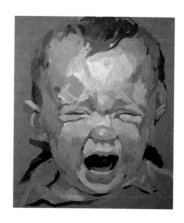

Right: *Robert Maxwell Wood,* Edward and Tears *(gouache on cardboard). The stretched lips reveal teeth—the top ones more in shadow—and the tongue—dark but not quite black.*

What shape is the nose?

The nose occupies a most important position, linking the other features as well as all the fleshy areas around them. From the side it is roughly triangular, two elongated triangles, leaning together to form its length. At its base is another, much smaller, triangle. From the front too, its form is triangular, wider at the nostrils than at the bridge. The angles of these triangles must be judged correctly if the likeness is to be caught. In fact, by now you will have realized that the likeness depends on everything coming together in just the right way.

Left: Three drawings of the same nose seen from different angles—(left) front view, (center) three-quarter view, and (right) in profile.

How can I make the nose appear dimensional?

A three-quarter view will also help to make the nose appear more dimensional. While eyes and lips remain close to the curved surface of the face, noses and ears project out from it. A nose can cast a shadow like the gnomon on a sundial, and ears too can cast shadows on the face if lit from behind. In soft light a nose can be difficult to see as a projecting shape, especially from the front.

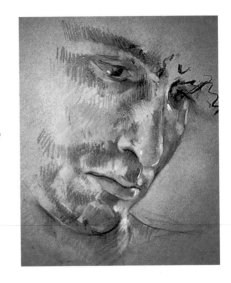

Right: *Robert Maxwell Wood,* Study for Compassion *(charcoal and pastel). In this study, the smallest specks of light are sufficient to describe a contour.*

How can I paint the front view of the nose?

Light and shade are the portrait painter's most valuable tools when painting the human face. The complex anatomy of the head and face—the bone and muscles, and the skin which covers them—are only seen by means of a constant source of light.

The front view presents problems because there are no contour lines to show that it projects forward. This illusion has to be achieved by handling the light and shade correctly. Highlights along the nose and at its tip are most helpful here. The nostrils should not be painted too round or too dark. When viewed from the front, they are seen at their narrowest and the shadow gradually darkens from below. Do not paint them as an ungradated dark shape unless that is truly the case. The fleshy areas containing the nostrils are also difficult. Do not overestimate the size of the nostrils or their distance apart. Note any shadows at the base and any difference in coloration of the flesh tint.

In a front view, be sure to observe correctly the length of the nose relative to the height of the forehead and length of the chin. Check it in relation to the shape of the jaw—this is very important.

Right: *The nose is basically a wedge shape that extends out from the face at an angle. To make this shape look dimensional it is necessary to have a light side and a shadow side along the length of the nose and also a shadow beneath. In this painting the artist painted a warmer tone between the shadow and light sides along the nose and also at the base of the nose as it recedes into the shadow. These warm tones visually advance and help to give the illusion of a three-dimensional form.*

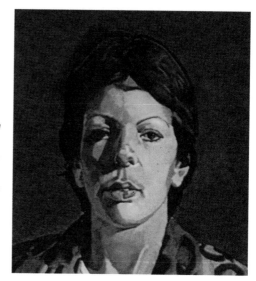

What color should I use for the nostrils?

Warm darks usually work better in the nostrils than cool darks. Observe the angles and shapes of the nostrils carefully and be sure not to make them too large, too solid, or too dark.

Right: *Colors to use in the nostrils could include burnt umber and alizarin crimson in the deepest areas, with touches of burnt sienna or even cadmium red as the nostril opens out. Colors to avoid are black, dark blue, or dark blue-violet, even if the nostrils appear to be those colors in a photograph.*

How do I deal with the nose in a profile pose?

Profile poses depend upon the careful observation of the angles of the forehead, nose, nostril shapes, and chin. Carefully chosen highlights will help the head in profile to have a more dimensional feel.

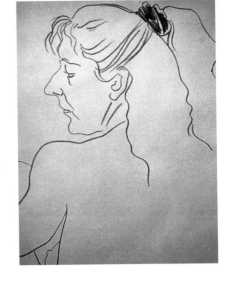

Right: *Robert Maxwell Wood,* Woman With Pony Tail *(black chalk). In this fast drawing, the artist has linked the nose and upper lip in a single line.*

How can I learn to paint ears?

Remember the basic facial proportions (*see page 11*) and place the ears correctly on your model (in between the eyebrows and the nose in a profile view).

From the front or partial side view the ears are foreshortened, so you must observe carefully and paint exactly the shapes that you see. These are set at some distance from the other features, on the side of the head. This distance is often under or overestimated. Careful measurement from ear to outer corner of the eye should clear up any problems. The ear springs from the head partly over the jawbone's joint with the skull (check this by feeling your own ear and jaw) and is most fully visible in a profile view. Its size and shape can vary greatly but is most usefully compared with the nose on a horizontal axis.

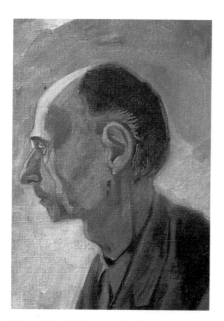

Above: *Ros Cuthbert,* Study of Cecil Collins *(oil on canvas). In a profile view the ear, if visible, becomes very important, occupying center stage.*

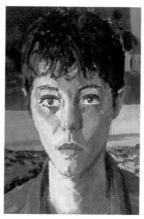

Above: *Jane Percival,* Honey *(oil on canvas). The subject is very slightly turned away from the viewer, looking over the artist's shoulder into the distance. The ears are small and not much of them is visible. Light first catches their top edges, each described by a single paint stroke. Notice that the top of the right ear is a steeper line than that of the left.*

Are there any other tips for painting ears?

It is useful to make a special study of drawing ears before you try to paint them, as they are quite complicated.

Ask a friend to sit while you draw his or her ear from the side, then from the front and back, and also from above and below. In this way you will gain a three-dimensional understanding of the forms and an appreciation of how dramatically they change depending on your viewpoint. Do contour drawings and tonal drawings before working with colors.

A child's ear differs from an adult's in shape, texture, and color. Earlobes can be long, short, or non-existent.

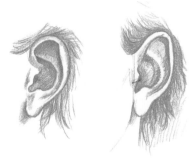

Left: *Three drawings of an ear seen from different angles—(left) from the side (profile view), (center) three-quarter view, and (right) from the front.*

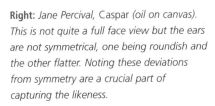

Right: *Jane Percival,* Caspar *(oil on canvas). This is not quite a full face view but the ears are not symmetrical, one being roundish and the other flatter. Noting these deviations from symmetry are a crucial part of capturing the likeness.*

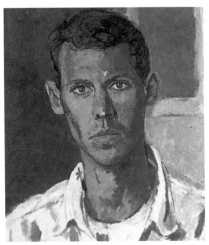

What color are the ears?

Ears are usually warmer and pinker in color than the face.

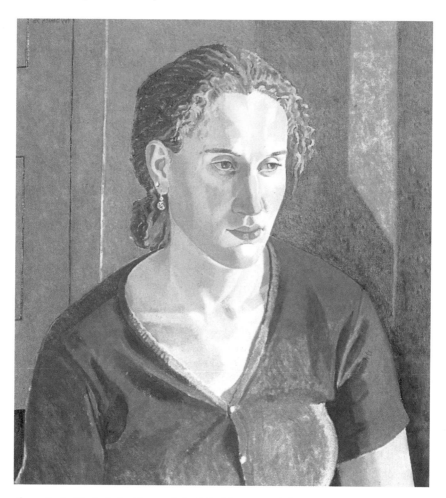

Above: *Ivy Smith,* Portrait of Rowan Entwhistle *(oil on canvas). Rowan's gaze is downward and her chin has dropped a little; consequently the ear is placed fairly high. The ear is fully modeled but painted more broadly and simply than the other features.*

How can I simplify painting hair?

Hair, especially thick hair, can obscure the shape of the scalp and the structure of the head. This makes it easy to overlook the fact that the hair grows from the scalp and that the shape of the hair is dictated partly by the shape of the head. The line where the hair starts and the face stops is a superficial one.

The most striking thing about hair is its texture. We see the thousands of individual hairs which make up the whole and we wonder how it can possibly be interpreted in a drawing or painting. Most artists treat the hair as a solid mass, looking for planes of light and shade within the overall shape. Texture is sometimes introduced into this established form, although many painters prefer to leave the hair in a comparatively simplified state. Even in some of the portraits by Frans Hals and Rembrandt, where the hair looks extremely realistic, it has first been established in more substantial terms.

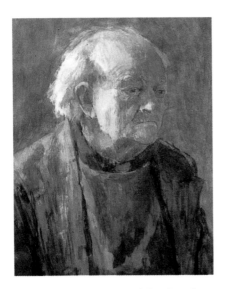

Above: *Helen Elwes,* Fergus *(oil on board).* *This old man's fine hair is portrayed using semi-opaque touches of pale gray over the darker background around the subject's head.*

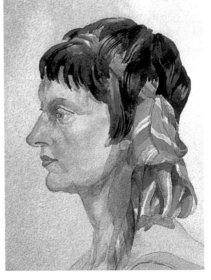

Above: *Jane Bond,* Harriett *(oil on board). A burnt sienna underpainting warms the dark hair tones. The golden highlights are painted wet-into-wet for a soft, silky appearance.*

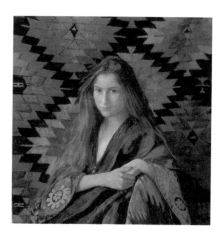

Left: *Brian Luker,* Profile of a Young Woman—detail *(watercolor). The hair has been treated boldly, the first wash going on wet-into-wet. The darks were added once this had dried.*

> **ARTIST'S TIP**
>
> In watercolor, the edges of the hair can be softened with a damp brush after they are dry to connect them with the skin areas in the parting and around the head.

How can I deal with a parting in the hair?

It is important to retain a sense of the skull beneath a head of hair, however wild and glorious it seems. When drawing in preparation for a portrait I am careful to note, or to sense if I cannot actually see, the skull's contour; and to paint the hair in relation to it. For example, if there is a parting it will follow the curve of the skull. Wherever the hairline is visible, it should be painted sufficiently softly to suggest hair growth rather than a wig.

Right: *Brian Luker,* Geoff *(pencil and watercolor). The parting in the hair should follow the shape of the head and can be a similar color to the skin tone.*

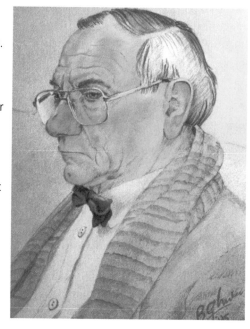

How can I paint the transition between the hairline and the forehead?

Remember to blend the tones together as the hair meets the forehead. Mix the tone color you see in the hair, perhaps a mixture of flesh tint and hair color. Too hard a shape will look totally false. It could be that the hair grows more thinly in some places. This should certainly be observed because the hairline defines and frames the face and an incorrect emphasis would jeopardize the likeness. In sharply focused, detailed portraits, brush marks should follow the direction of hair growth. Practice will show you how much detail is advisable. Use a very fine brush for single hairs and keep the paint thin. Too much detail can easily look fussy. A few simpler marks over an underpainted base might suffice. It all depends on your style.

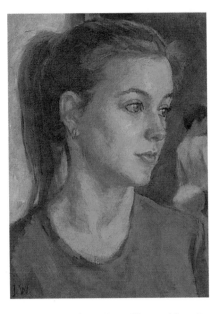

Above: *Notice the variety of lost and found edges around the hairline in this portrait. Where the hair lifts up there is a shadow tone below and where it grows out from the head there is a soft lost edge between the skin and hair as the two tones are slightly blended together.*

ARTIST'S TIP

Edges where the hair and flesh tones meet should be soft to avoid the hair having a "pasted on" look. Soft edges are achieved in oil and acrylic by blending wet paint areas together. In watercolor, soft edges are achieved when two damp paint areas meet, or by softening the edge with a damp brush after it is dry. In pastel, edges can be softened and blended either with the fingertip or a torchon (*see pages 147 and 188*).

How do I paint very curly hair?

A head of hair can be a complicated mass of curls or waves, and as such very confusing to the eye. One way of coping is to draw in the leading edges and shapes of locks of hair with the point of a brush. Next, block in the darks with a broad brush—a flat or a filbert. Paint in the most prevalent tone color of the hair elsewhere and begin to blend these, looking for changes in color due to natural coloring or an increase of shadow. Finally, paint the lighter areas and the sheen or highlights. The movement of the paintbrush should follow the lines of the hair—look for the areas of light and shade rather than the details; these can be suggested last. Do not forget that too much detail is often distracting and that looking at your subject with half-closed eyes helps to simplify things.

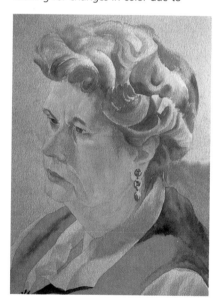

Above: *In watercolor, it is necessary to leave the light areas of the subject as the white of the paper. Here the artist has separated the curls into light and darker areas with the lights separating each section of the pattern of curls across the head.*

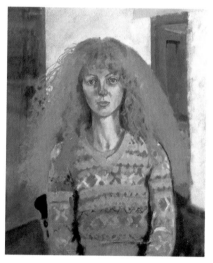

Above: *Painting back and forth between the hair color and the skin tone to drag a little of each color into the other will help to make these transitions softer and more lifelike.*

What do I need to know about painting eyebrows?

Eyebrows and eyelashes should not be painted too heavily, and differences in length and thickness of the hairs should be noted. To a skilled hand the eyebrows can be a single stroke beginning at the inside, which is generally denser and wider, the lessening of paint on the brush coinciding with the petering out of the eyebrow. However, an eyebrow is not necessarily a single continuous arch but might be angled like a circumflex, or even quite straight. The direction of hair growth will vary, nor will the top edge be exactly parallel to the lower. Do not lose the "spring" of the shape in your concern over individual hairs.

Remember that the eyebrow follows the contour of the ridge of the forehead. Its position relative to both nose and eye should be correct, as any inaccuracy here can result in a change in likeness and/or expression.

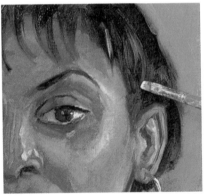

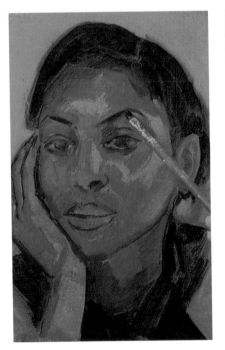

Left: *The artist blocks in the background with a mixture of cadmium orange and cadmium red, and strengthens the hair, eyes, and eyebrows with sepia.*

Above: *Using ivory black and sepia, the fringe is pulled forward over the forehead and the hair is completed.*

How do I paint beards?

Beards are always interesting to paint, from the wild, untrained variety to the clipped, manicured type. I am always intrigued to see which parts of his beard a man decides to keep or shave. There really are a million approaches to beard gardening!

A beard can be treated in much the same way as a head of hair. Firstly, a man's beard may well be a different color and certainly a different texture from his hair. Also, the beard's hairline is bound to vary in density around the face and special care should be taken to mix the correct tone color for these areas so that the beard looks natural. If partly shaved, the skin showing may be bluish, especially if the man is dark-haired. If your sitter has a mustache, consider its relation to the upper lip, which it may obscure, and remember that its shape will follow the contours of the face.

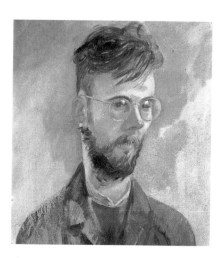

Above: *Ros Cuthbert,* Gerard *(oil on canvas). The paint was kept very thin in this study, which took about an hour to complete. The work depends on thin washes of paint and fast brushwork for its liveliness.*

Above: *Stina Harris,* Portrait of Ian Clayton *(oil on canvas). Here, the beard and hair are quite different colors and textures. Notice how the beard blends into shadow under Ian's chin.*

CHAPTER

6

CLOTHING
AND HATS

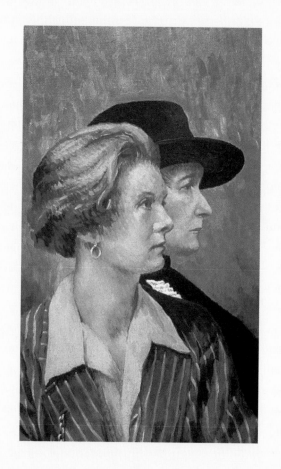

Should I ask my model to wear particular colors for the portrait?

You and your subject may have different ideas about which clothes should be worn for the portrait. Sitters may want to wear something in keeping with their image of themselves, a sweater or shirt which has special associations, or a garment that they consider suits them particularly well. You, the artist, will be looking for effects of tone and color, for textural contrast, and for the overall shape as it will look in the composition.

The painter who likes bright colors and patterns may be dismayed if the subject insists on wearing plain gray, but a striking and contrasting background can often solve the problem. Usually a compromise is not hard to find, and serious disagreements are rare.

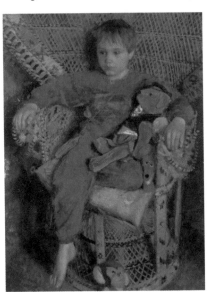

Above: *Jane Bond,* Tristan *(oil on board).The subject is dressed comfortably and looks relaxed. The blue of the pajamas contrasts with the orange tones of the surrounding elements in a complementary way.*

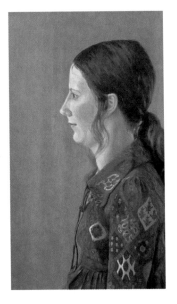

Above: *Jack Seymour,* Jean *(oil on board). The pattern of the dress adds detail to this simple profile view. The artist used a muted blue/green in the background to contrast with the red/orange in the dress and hair.*

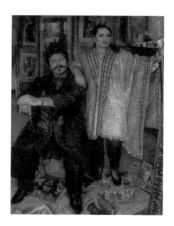

Left: *Barry Atherton,* Portrait of Adele and John Godoy Quinn *(pastel on handmade paper laid on a wooden panel). The contrasting light and dark clothes allow you to read the shapes more easily. The middle tones in the floor and background shapes contrast with the lighter and darker parts of the figures. The dark area above Adele's outstretched arm and the repeated rectangle shapes throughout also add interest.*

What is the general rule for painting clothing?

Drawing and painting fabrics should not present any real problem. As with skin, it is a mistake to overwork the clothes, which are usually best treated in broad terms in the early stages.

Clothes should be developed as part of the whole image, and should generally not be allowed to become more explicit than other elements in the picture. Clothing may add drama or focus to the painting, but the clothing choices in the portrait can also be enhanced by the judicious use of color and tonal contrast.

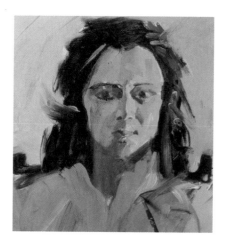

Above: *Here the artist has used acrylic paints on paper rather than canvas to make a quick, but detailed, study. The artist established the colors and tones of the clothing along with those of the face and hair.*

How do I paint different types of fabrics?

Different fabrics call for different treatments. Artists of the past have perfected the depiction of lace, velvet, brocade, and other richly textured materials to an amazing degree.

Whatever the texture of the fabric, its shape is almost always dictated by what is underneath. This is true of all but very stiff or heavily gathered fabrics. Softer ones, such as satin and thin cottons, generally reveal the contours and volumes of the underlying form, and textiles with a surface pattern are often helpful in describing form.

How can I learn to paint the folds in cloth?

Clothing is difficult to paint if you are afraid of painting folds in cloth, and if this is the case, some special practice would be wise. Throw a non-patterned dress or coat over a chair and make studies, both in pencil and paint, of the way it hangs. Heavy fabrics will hang in bulkier folds, shiny ones will have bright, sharp highlights, diaphanous ones will show in layers of graduated tone color. Velvet is discernible from woven tweed because it holds more light in the pile. Creases in satin are likely to be more brightly, sharply highlit than creases in cotton. Having drawn in the contours, find and paint the darkest parts, then paint in the brighter areas, and finally the highlights. A simple method such as this can be a good place to begin.

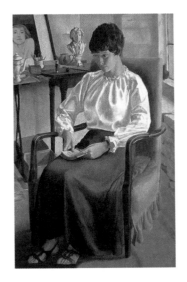

Above: *Jack Seymour,* Janet *(oil on board). Janet's cotton shirt is painted in three basic shades of white, pale gray, and mid-gray. The skirt, apparently made of heavier fabric, hangs in simpler folds.*

Do you have any suggestions for painting patterned fabrics?

Clothing is often painted simply so as not to detract from the face. The degree of emphasis is up to you, but begin by mastering plain fabrics before tackling patterns, stripes, and textures. Clothing offers many possibilities for composing with color and pattern. However, it is worth noting that a master such as Rembrandt often suppressed the light on his sitters' costume to spotlight the head.

1 To create the pattern of the coat, first describe the lighter pattern and fill in the white areas with a darker tone.

2 With a clean, dry decorators' brush, blend the colors together with a feathering motion, the brush just lightly touching the surface.

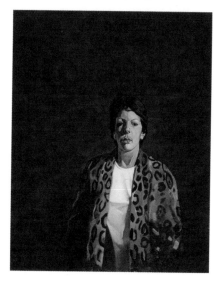

Above: *One of the most interesting aspects of this painting is how few colors were used. The artist has relied only upon tones of burnt umber, burnt sienna, ocher, and white for almost the entire painting.*

3 Rough-in the background with the decorators' brush. To obtain a clean edge between background and figure, use a smaller brush.

4 Moving into the figure, the shirt is carefully described in tones of gray and white.

Are there other techniques to use for painting patterns in clothing?

You can use acrylic paint to stencil areas of color. Paint a basic background tone to suggest the light and shadow shapes of the clothing. Then apply the patterns and stencil shapes in a way that flows around and follows the shapes of the form.

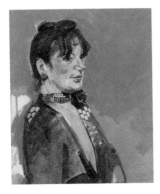

1 *Start to paint the pattern details using vivid colors. Use the point of a brush, keeping the color thick and opaque.*

2 *Use a stencil to apply small pattern areas. Angle the dots to describe the directions of the form. Paint larger shapes by hand.*

3 *Using a stencil, block in dots of yellow over the dry paint surface.*

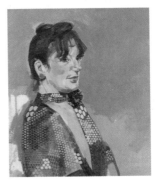

4 *Modify the dots by further applications of color to vary their shape and size.*

How can I learn more about painting clothing?

Understanding how the body is foreshortened in different poses will help you when you are painting the clothing that covers it. An awareness of anatomy (*see page 10*) may be most useful when considering a figure disguised by clothing. The portrait painter will often be confronted with a figure in which the only evidence of observable anatomical structure is in the hands and head. It is often necessary to decipher the structure of the body beneath the clothing as this makes it easier to imply the solidity of the figure.

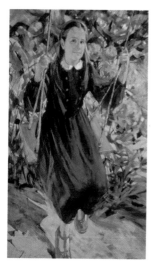

Above: *Ann Hicks,* Girl on a Swing *(oil on board).* The light reflecting up from the ground illuminates the girl's dress as well as her skin which, on the shadow side, acquires a bright yellowish tint.

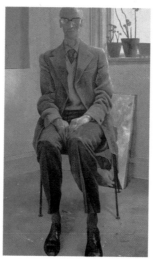

Above: *Ros Cuthbert,* The Reverend Alan Grange *(oil on canvas).* The artist sat close to the subject, and so his knees and feet were closer to her than his head. As a result, his head appears relatively small and his shoes exaggeratedly large.

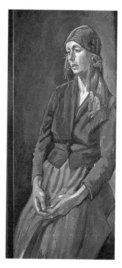

Above: *Hugh Dunford Wood,* Portrait of a Woman *(oil on canvas).* Stark lighting has created dramatic light-dark contrasts. Note how the stripes in the skirt are omitted in the shaded area.

How can I paint clothing in a realistic way?

Studying paintings by the old masters and other accomplished painters will help you to see how they painted fabrics in a realistic way. Close observation of color and light are necessary to do this.

In this example, the artist has used acrylic paints on paper rather than canvas to make a quick, but detailed, study. The colors are muted but warm and glowing. Areas of neutral brown are enlivened with touches of green and dark red in the shadows. The effect of bright, artificial lighting is enhanced by a strong cast of yellow in the highlights.

1 Block in the basic image in thin color washes.

2 Intensify the tones with washes of black, brown, and blue. Lay in solid blocks of color.

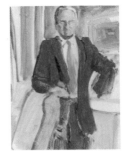

3 Use thicker paint to lay in light flesh tones and shadows. Work over suit.

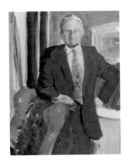

4 Strengthen the background color and block in the chair. Show folds in the suit.

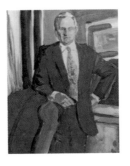

5 Work up details of the face and hands with contrasts of light and dark flesh tones.

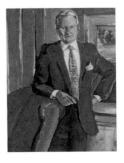

6 Redefine details; add highlights with thick color. Lighten the background.

How can hats add interest to a portrait?

The clothes we wear are important to us, not just as a protection against the elements, but also because they express our personality and often our status. Official portraits usually portray the subject in a uniform, or in ceremonial clothes—the Chancellor of a university, for example, will be shown wearing his robes of office.

Hats are particularly important to the portrait artist because they can be used to emphasize the personality of the subject. Just think of a young child's straw bonnet and contrast it with the worn and battered headpiece of an elderly person who has worked in the fields, exposed to the elements all his or her life. The shape of the head and features can be shown to advantage when their contours are thrown into sharp relief by the shadow cast from a brimmed hat.

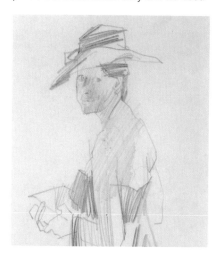

Above: *The hat throws the subject's face into almost total shade, giving an impression of intense heat and strong sunlight. The hat also plays an important role in the composition of this drawing. A strong, horizontal shape, the dark hat picks up the tone of the dress, and this dark tone acts as a "frame" to the head and shoulders.*

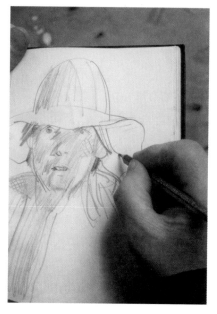

Above: *This drawing shows how a hat can create a personality. The subject looks quaint and old-fashioned because of the shape of the hat she is wearing.*

Are there more examples of using hats in portraits?

Hats, scarves, and head coverings can add mystery, shape, color, pattern, drama, history, humor, and more to a portrait. They should not be overlooked as a valuable addition to a painting. Look at the images in the previous chapters to find more ideas about how hats can affect the feeling of the portrait.

Left: *Jerry Hicks,* Kim's summer hat *(oil on canvas on board). In this painting about light and shadow, the hat is the focal point due to the bright color and tone contrast, then we read the subtle shaded face and figure.*

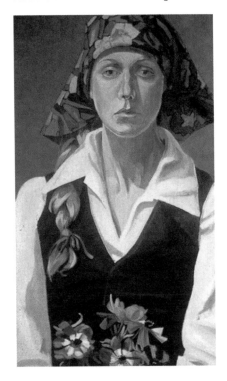

Right: *Hugh Dunford-Wood,* Emma *(oil on canvas). The head scarf provides interesting positive and negative shapes and tonal contrast to the top part of the painting. The light and dark shapes, front view pose, and strong side lighting contribute to the drama of this portrait.*

How can head coverings be used as a device in composition?

One way to do this is to use the covering to provide a contrast to the background. In this painting, the white turban stands out against the shaded background and helps to emphasize the shape and contours of the head.

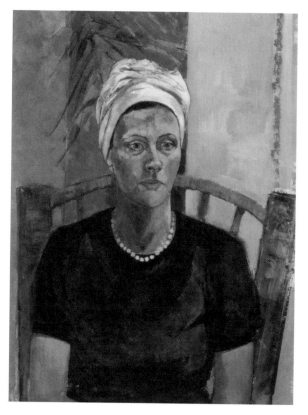

Above: *Head coverings can be used very successfully to add an extra shape or perhaps a splash of color—or both—to your portrait compositions. Although the figure is placed squarely on the canvas and fills the space, too rigid a symmetry is avoided by placing the fern off-center at the top. The pearl necklace echoes in form and color the white turban framing the face.*

CHAPTER

7

DRAWING AND SKETCHING

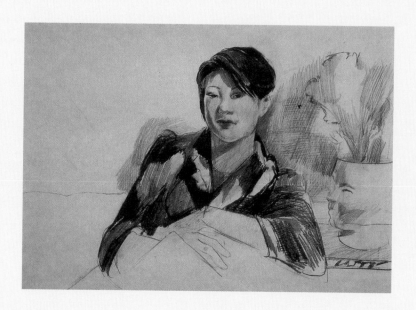

What materials will I need to draw and sketch portraits?

Learning to draw gives you a wide choice of materials, most of which are easily obtainable and relatively inexpensive. If you are unaccustomed to drawing, it may be wise to start with a pen or pencil.

SUPPORTS
The most usual support for drawing is paper, and there is a wide range of colors, textures, and weights available. You can also choose between books or pads, some of which are small enough to carry around in your pocket, and large sheets for use on a drawing board. Good-quality drawing paper is made from rags and comes in linen and cotton.

PENCIL
The lead, or graphite, pencil is the most common and accessible of all drawing equipment. The lead comes in varying degrees of softness—a very soft lead enables you to make broad, soft lines, whereas hard leads are generally used for fine, precise lines and detail.

The most common categories run as follows, from the very hard to the very soft: 8H, 7H, 6H, 5H, 4H, 3H, 2H, H, HB, F, B, 2B, 3B, 4B, 5B, 6B, 7B. The majority of H pencils are for technical or office work. The B and 2B are probably the most popular and easy to use, and you should start with these.

Also available are extremely soft pencils which sometimes have a flattened lead, and which are outside the above range. These produce dark, tonal drawing which is especially effective on rough, granular paper.

CHARCOAL AND CONTÉ CRAYON
For large, tonal drawings, charcoal is unbeatable. It is particularly useful for roughing out the composition prior to painting with oils or acrylics. It can be used on primed canvas or board, is easy to rub out and correct, and can be rubbed down to a faint outline which does not mix with the color of the paint. You can buy charcoal made from willow or vine. It also comes in pencil form or as compressed sticks, although these are harder than the natural charcoal.

The best eraser for charcoal is a kneaded rubber eraser. This rubs out easily and can be used to lighten tones, for blending, and for drawing lighter shapes into dark areas already toned with charcoal. Charcoal tends to smudge, so take care. When your drawing is complete, spray it with a fixative to prevent further smudging.

For tonal drawing, use charcoal on white paper. This will enable you to exploit the extreme contrast between lights and darks. Rough paper is best for

1 Crayon in holder
2 Conté crayons
3 Sticks of willow charcoal
4 Charcoal crayon
5 Watercolor pencils
6 Lead pencils
7 Calligraphy felt pen
8 Fine fiber-tip pen
9 Brush pen
10 Plastic eraser
11 Craft knife
12 Conté crayon holder
13 Sandpaper block
14 Colored pencils

this because the soft charcoal tends to slide off a smooth surface. Using charcoal with white chalk will allow you to work highlights into the drawing.

A similar effect can be obtained with conté crayon. This is usually sold in broad sticks, which are unsuitable for detailed work, but is also made in pencil form. Conté is harder than charcoal, which makes it easier to manage but more difficult to erase. It is usually available in black, white, sepia, and a brownish-red.

COLORED PENCILS

Colored pencils are a very useful sketching and drawing tool, producing a compromise between a lead line-drawing and a painted image. They are softer than lead pencils, but are more difficult to rub out. Mistakes usually have to be scraped off the paper with a sharp blade. Colors cannot be pre-mixed, but you can mix them "optically" on the paper by lightly overlaying different colors (*see page 84*).

WATERCOLOR PENCILS

Watercolor pencils are a comparatively new medium which is available in an increasingly wide range. These are a cross between colored pencils and watercolor paints. Apply them in the normal way, then use a fine sable brush dipped in water to blend the colors together, thus creating the effect of watercolor. This is a surprisingly flexible medium, allowing you to produce tightly controlled work with well-sharpened pencils and a fine sable brush or, rugged, textural areas of spontaneous pencil marks and loose washes.

PEN AND INK

The traditional dip-pen has changed little over the years. You can vary the line—something that is impossible with ballpoints and felt-tips. Many artists prefer the dip-pen for this reason, but there is no reason why you should not try both. The modern pens are certainly more convenient because you do not need to carry a bottle of ink with you.

The most vital part of the equipment is the nib; obtain a variety of these to see which suit your particular needs. A fountain pen is handy for outdoor work.

There is an ever-increasing range of felt- and fiber-tipped pens and markers. Some have a flexible tip, but most make even, uncompromising lines, and many artists dislike them for this reason. However, they are convenient, disposable, and easy to carry around.

TECHNICAL PENS

Technical pens are specially designed for creating lines of an even thickness. They are good for drawing that involves hatching and cross-hatching. Many artists feel it is a rather unsympathetic medium, but it need not be so; the success of a technical pen drawing depends on the style and attitude of the artist.

1 Dippers from drawing ink bottles
2 Japanese ink sticks
3 Japanese brushes
4 Synthetic flat
5 Small synthetic round
6 Nib units from Rotring technical pens
7 Colored papers
8 Watercolor papers
9 Drawing paper
10 Sketching nibs from fountain pens
11 Colored inks
12 Dip pens

Why is the choice of paper color important in a drawing?

The choice of paper is the first thing you need to consider when beginning a drawing as it will crucially affect the way that the work proceeds.

When making a drawing on white paper, every mark, however dark or light, will be darker than the surface and will consequently imply contours or areas of shade.

On the other hand, when working on darker paper, the addition of light marks will imply those areas of the subject that are affected by light.

Many paintings and drawings consist overall of a large area of middle tones with some lights and darks. By starting a sketch or drawing with a middle-toned paper you are free to focus on drawing only the light and dark areas of the subject knowing that they will be immediately supported by the middle-toned surface.

What is meant by directional pencil strokes?

The direction of the pencil strokes can play an important part in describing form. Because pencil is essentially a linear medium, it can be difficult and time-consuming to suggest large forms through light and shade. These examples show how different artists have treated this technique. (*See also page 89.*)

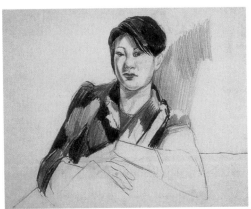

Left: *Here the artist has carefully used the direction of the pencil strokes to help indicate form. The material on the gown is sketchily treated, but the loose drawing follows the direction of the folds of the garment to show the underlying forms of the subject's arms, shoulders, and chest. The hair is not treated as a solid shape, but is built up from lines of color that follow the fall of the hair.*

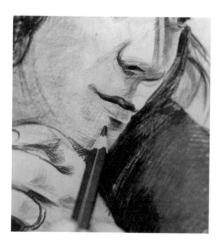

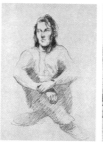

Above: *The shadow areas on the face are developed with diagonal strokes of soft gray tone. Both the tone of the pencil and the direction of the strokes help give the impression of depth and form.*

Above: *In the final stages of this colored pencil drawing, the artist reworks dark detail areas of the face with a strong blue pencil.*

What is cross-hatching?

Cross-hatching is a method of building up areas of shadow with layers of criss-cross lines rather than with solid tone. These details are often developed in the final stages of a portrait drawing. The example below shows how these overlaid lines can be used to build up the dark shadow areas. Keep the pencils well-sharpened and apply each layer of lines systematically to give yourself maximum control over the texture and depth of tone you wish to create.

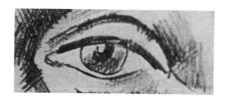

Above: *This drawing of an eye, using cross-hatching, shows the use of strong shadow areas.*

What are the steps for making a quick sketch in pencil?

The goal of a quick sketch is to capture only the essential and outstanding characteristics of the model as quickly as possible. A labored and detailed drawing would allow the artist to study, correct, and change the drawing; but a quick sketch demands that the artist be able to accurately render the subject, since he will not be able to correct and revise it later.

Above: A photograph of the model used for this portrait.

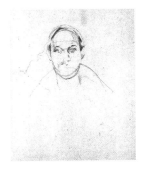

1 With a 2B pencil, sketch the shape of the head. Use light strokes to position features.

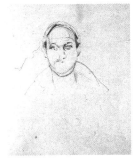

2 Work shadow areas around eyes with light cross-hatching, following general contours.

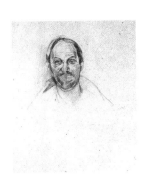

3 Crosshatch shadows to bring nose forward. Develop face with light, spaced strokes.

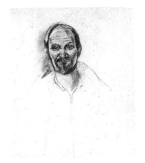

4 Darken shadows with 4B pencil. Erase highlights or lighten tones with putty eraser.

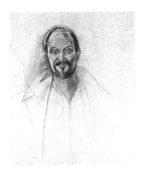

5 Draw in the neck and shirt collar. Darken all detailed areas with contour strokes.

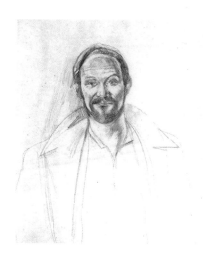

6 Blend shadow area in neck with torchon. Put in shadow area outside face and blend. Erase back into face highlights.

How can line be used to suggest volume?

By varying the pressure on the pencil, a line of different intensity will result, and by the addition of tone in relation to the effect of light and shade, a more substantial indication of volume can be realized. Alternatively, the contour may be broken or the directions of lines changed to indicate different planes. In the case of describing a face, certain points around the contour may reveal the overlapping of one form over another.

Above: *Notice in this sketch of a sleeping child how the line is varied in weight and the contour is broken to help describe not only the form of the face and clothing but also a sense of the direction of the light.*

Can pencil also be used to draw on toned paper?

Apart from imparting a colored background to the drawing, toned paper can also serve as the tone in many parts of the subject.

Choose a mid-tone paper with fairly neutral color to start. Graphite pencils can be used for the darker tones of the subject and white pencil can be added to create the highlights.

You may find it helpful to make a small tonal chart on the paper before you begin, to decide where the tone of the paper will fit in with the tones of your subject.

Start the drawing with a simple outline of the subject, then gradually build up the darker tones and, finally, add the highlights.

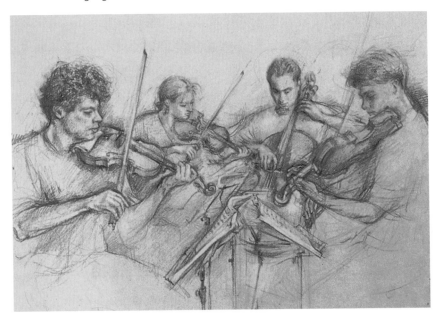

Above: *Rachel Hemming Bray,* Skampa Quartet *(soft pencil on canson paper). The warm tone of the paper adds atmosphere and a timeless quality to this drawing. It was done in a small practice room—the artist was so close to the players she was unable to see the group all at once.*

How can even tones be achieved with colored pencil?

You can obtain any color you need by blending two or more colors together. Apply the first color in light regular strokes, keeping the color as even as possible—if the pencil is used too heavily other colors cannot be laid on top. Lay the second color in the same way, taking the pencil strokes in the opposite direction. If you use too many colors, the translucent quality of the blended color will be spoiled. The top color will usually be the dominant one. (*See also page 84.*)

Left: *If you lay red over blue, the result will be a red-purple or maroon, whereas blue on top of red will produce a blue-purple.*

Left: *Here, the artist blocks in the background with light gray, applying color in a series of cross-hatched areas of irregular tone. The artist does not create deeper tones by pressing harder—instead he uses a light, even stroke, darkening the color by building up extra layers of hatching and cross-hatching. (See also page 135.)*

What are the steps for making a portrait drawing in colored pencil?

Colored pencil drawings can also be started with a drawing made with an F pencil.

In this example, although the artist has used line to develop tonal areas, the method of drawing is similar to the classic oil painting technique of laying down colors one over another to "mix" new colors. This requires a confident use of color, as once put down, colored pencils are not easily erased. This, combined with subtle or strongly directed strokes which follow or exaggerate the planes of the figure, creates a powerful image.

An interesting feature of the composition is the use of the white paper within the figure to describe the face, hands, and hair highlights. In the model's left hand, one simple line is all that is needed to separate the figure from its environment. The nearly bare areas of the face and hands are heightened by the surrounding dark area, which, in turn, plays off against the white of the paper.

1 Sketch outline of the face in raw umber. Use ultramarine blue for shadows, hair, and—using light strokes—blouse.

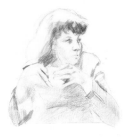

2 With pale green, using hatching and cross-hatching, define shadow areas of face. With dark blue, add eye detail.

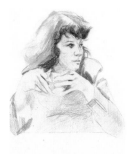

3 With red and yellow, define hair. Strengthen outlines of face with ultramarine blue. Put in shadow to right of face.

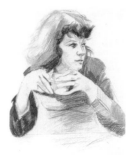 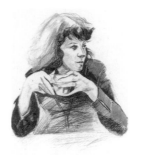 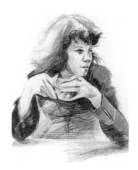

4 Work into hair with red directional strokes. Overlay light strokes of blue and red in blouse with loose strokes.

5 Overlay magenta area with red. Create stronger shadow areas with ultramarine blue.

6 Work back into hair with burnt umber. Use pale green to put in highlights in the cup.

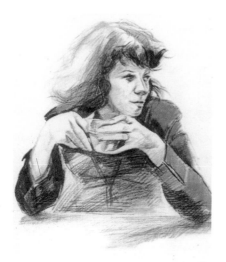

ARTIST'S TIP

Overlaying colors is a good way to mix colors when using colored pencil, but overlaying more than two or three colors, too solidly, can make areas that look overworked and muddy.

Above: *This picture is a good example of the effective use of colored pencils in portraiture, especially when combined with the color of the clean white surface.*

How can I draw a portrait in India ink?

You can start with a light pencil drawing (HB or F) to outline the head and features, and to indicate the light and shadow areas.

A strong image is constructed by hatching and stippling. The drawing uses high tonal contrasts, but note that there are no solid black areas; the darkest tones consist of layers of dense cross-hatching built up in patterns of parallel lines (*see page 135*). Details of texture and shadow in the face are stippled with the point of the nib. The vigorous activity in the drawing is offset by broad patches of plain white paper indicating the fall of light over the form.

Observe the subject carefully, moving the pen swiftly over the paper. The pen strokes should be loose and lively or the result can look stiff and studied.

 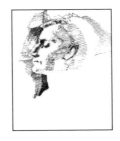 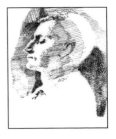

1 Hatch in a dark tone down one side of the head to throw the profile into relief. Continue to build up detail in the face.

2 Work on shadows inside the head with fine parallel lines slanted across the paper. Work outwards into the background.

3 Broaden out the shadows and crosshatch areas of the background behind the head to darken the tones.

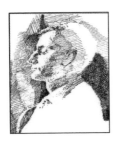 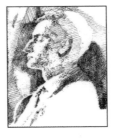 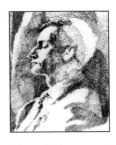

4 Vary the background tones, covering more of the paper. Add detail to the clothes and head.

5 Add dark tone to show folds in the clothing. Define hairline and ear with cross-hatching.

6 Intensify the tones with hatching and stippling. Develop contrasts.

What are the two kinds of ink?

There are two kinds of ink: waterproof and water-soluble. If you use the soluble kind, the lines can be practically rubbed out with water after being applied, and even after they dried. This gives a flexibility to the process.

Left: *Water-soluble ink lines can be blurred by dragging a wet Chinese brush across them. This will cause those areas to recede, and creates a sense of form and depth in the drawing.*

How can white paper be used to model the face and figure?

The color of the paper can be left to describe the strong light areas of the image. The paper can be used within a figure to describe the face, hands, and hair highlights. (*See also pages 140 and 146.*)

Right: *The initial pencil sketch of the head is used only as a reference for developing shadow and highlight areas. Note how the shadows within the face and in the background create the profile of the head.*

What is contour line and how could I use it in an ink drawing?

A contour line drawing is essentially an outline drawing which emphasizes the shape of the subject rather than details of it. Contours within the shape are also drawn to give a three-dimensional perspective.

In this pen and ink drawing of an old woman, there has been no attempt to take the whole drawing to the same degree of completion; areas of the subject's coat are left white and others are indicated by only light areas of tone.

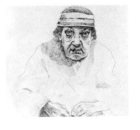

1 Establish the basic composition in a linear manner before concentrating more fully on the face.

2 The eyes are a point of focus; to compensate for their prominence, add intense shading under the brim of the hat.

3 The form of the head is suggested by a build-up of cross-hatching. The hands are treated in a similar fashion.

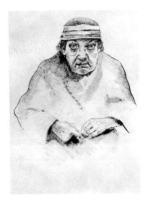

5 In the final stage of the drawing, the contours have been given more emphasis, using a relatively thick, definite line which contrasts effectively with the spidery marks of cross-hatching.

4 To increase tonality and add depth, shadow to side of head and under the hands is blocked in completely.

What is stippling?

Fine shadows and texture can be created by stippling with pen and ink.

Right: *The artist develops shading with a series of tiny dots, varying the density of these to create lighter or darker shadows. The dots are used to complement the more formal cross-hatched shading, creating a marked difference between soft, irregular texture and contours and larger, angular tonal areas.*

How can ink lines be softened in a drawing?

Water-soluble ink can be used with a dip pen in the same way. Soft watercolor brushes can also be used to soften ink lines drawn with water soluble ink. Chinese brushes are softer than ordinary watercolor brushes. They have fine hairs and are useful for soft, irregular washes and creating delicate flecks of color.

Above: *The artist uses a Chinese brush with water to soften the hard pen lines and to create a wash with the released sepia color.*

Left: *To soften the regular technical line, the artist works on slightly damp paper. This makes the ink bleed to give an irregular line.*

Are there other ways to draw the face using ink line?

Use a broken ink line sparingly to define the outlines of the face and clothing, the direction of hair growth, and a little tone hatching. Add light ink washes to indicate some lighter and middle tones. A more graphic style relies on a strong ink outline to establish the shapes of the head, neck, and clothing, with lighter lines to indicate plane changes within the face. Add a strong black wash of·ink in the hair, broken by white paper areas, to suggest the direction of hair growth.

Can charcoal be used for a portrait sketch?

Charcoal and conté crayon lend themselves well to the type of treatment where the accent is more on contrasts of light and shade than descriptive work.

Above: *This sketch was drawn in charcoal and conté crayon using a photograph as reference. A comparison indicates that the artist's intention was not to reproduce a strict likeness, but to suggest certain qualities of light. One of the difficulties of working from photographs is that the drawing might turn out to be too static, but here the looseness and spontaneity of the charcoal medium confers a greater degree of liveliness than existed in the original photograph.*

Can charcoal be used for more finished drawings?

Today charcoal is regarded more as a medium suitable for sketching, but it can be used for very detailed, highly finished work. In the early sixteenth century, Albrecht Dürer executed portraits in charcoal and the crisp lines and subtle modeling display his skill as a draughtsman and his control of the medium. Later in the century, Michelangelo Caravaggio used charcoal to create tonal contrast rather than a linear construction in his drawings.

What is a torchon?

A torchon (or tortillon) is a stump, often made from rolled paper or chamois, which is used for blending charcoal and pastel in a drawing. (*See also page 188.*)

What is blending?

Like pastel, chalk and charcoal can be blended by rubbing the two materials together, or by laying one over the other on the surface of the drawing.

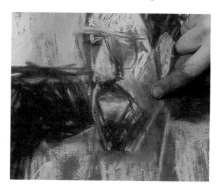

1 The artist uses the side of a chalk stick to apply black over white to create a broad area of middle tone.

2 She blends the black and white into a smooth gray with her fingers. Use a soft kneaded eraser to reveal the color beneath.

How can I use conté crayon to make a portrait drawing?

Conté crayons can be sharpened to a point to use for more precise drawing.

In this example, because the paper is already toned, the shadows do not need to be heavily worked, but the lights do need to be highlighted. White is drawn into areas of the nose and lower cheek to give a greater impression of volume. The back of the head and the left ear are delineated.

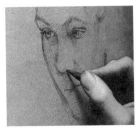

1 Use a black conté crayon to establish the side of the face, brow, and right eye, then add precise detail.

2 The cheek, chin, nose, lips, and left eye are drawn in separately.

3 The back of the head and the left ear are delineated.

4 Soft white conté pencil is used to describe spots of light.

5 Gradually the highlights are built up. Broad, softer lines are used to show the movement of the strands of hair.

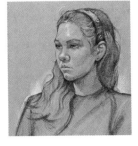

6 White is used in the background behind the shoulder to emphasize the figure on the paper.

How else can I use conté crayons?

Many of the old masters made preparatory sketches for their paintings in red or black chalk (conté crayon). For example, Michelangelo used red chalk sketches to come to terms with the desired image in his mind. Similarly, Holbein used black and red chalk, highlighted with white chalk and watercolor, for preparatory sketches which show his mastery of line.

What is fixative and why would it be used?

Fixative is a thin varnish which is sprayed on drawing media, especially charcoal and pastel, to prevent smudging and to protect the surface. Chalk drawings must be fixed, because the loose powder is easily rubbed off the surface of the paper, blurring the image.

The fixative is sprayed onto the finished work and binds the loose particles of pigment to the ground. You can also use a light spray of fixative over the earlier stages of a work. If you use fixative before the work is finished, it must be extra light—fixative is a varnish and chalk or pastel slides over a very hard surface.

Fixative can be bought ready-made in convenient aerosol cans, or it can be bought in bottles, in which case you will need a mouth spray, or atomizer. Hold the can about 12 in (30 cm) away from the paper, and spray from side to side, gradually moving downward, until the whole support is covered.

Several light coats are better than one heavy one, for a soaking may cause colors to run and affect the crispness of the image. Pastels can be fixed from the back as well as the front, depending on the drawing and the amount of pigment on the surface. (*See also page 188.*)

Above: *To preserve the sharp tonal contrasts and to prevent smudging, the artist sprays this finished charcoal drawing with fixative.*

OIL AND ACRYLIC

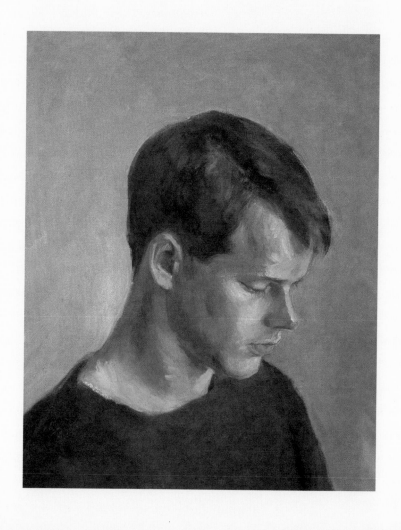

What materials do I need to paint a portrait in oil?

The essentials of oil painting are a selection of paints, some 00 brushes, a palette, turpentine or mineral spirit, and a surface to paint on. This surface, or support, can be primed canvas, or a less expensive alternative such as Masonite. Other items, such as painting knives, can be added as you progress.

SUPPORTS

Oils are traditionally applied to prepared canvas, although wood, Masonite, cardboard, and paper are all suitable, if they have been properly prepared. Primed canvas, canvas boards, and pads or sheets of specially prepared oil paper are available ready for use. Alternatively, you can prepare your own supports, which is the cheapest method and allows you to control proportions and texture.

Stretching your own canvases is easy. There are various fabrics to choose from, the best being linen because it stretches well and provides a taut, receptive surface. Cheaper alternatives are cotton, linen crash, and a mixture of linen and cotton. The wooden stretchers are available in different lengths.

To stretch your canvas, assemble the frame by fitting the four stretcher pieces together. Cut your fabric slightly larger than this frame—about 3 in (75 cm) all around. Place the fabric on the floor and lay the frame over it. The supports are usually beveled along one side to prevent a sharp edge from showing on the canvas. This beveled edge goes along the inside of the frame. Starting with a long sides, fold the fabric over and staple or tack it to the back of the stretcher. Repeat on the opposite side. Continue fixing the fabric in this way, starting from a central point and working toward a corner. Repeat on the opposite section, and continue until all the sides are firmly fixed to the support.

Whether you use canvas or another fabric, it must be sized and primed before use or the paint will simply sink into it. Size—or animal-skin glue, if you are using this—usually comes in crystal form. This is dissolved in water over heat, then brushed onto the fabric while still warm. The fabric tautens as the size dries. When the size is dry, apply a coat of ground or canvas primer to the canvas. This seals the fabric and provides a good surface to paint on. You can buy grounds in artists' suppliers. An alternative, used successfully by many artists, is ordinary waterbased house paint.

Acrylic primers are fine for use with oils, but oil primers must not be used for acrylics. Many commercially prepared surfaces are suitable for both.

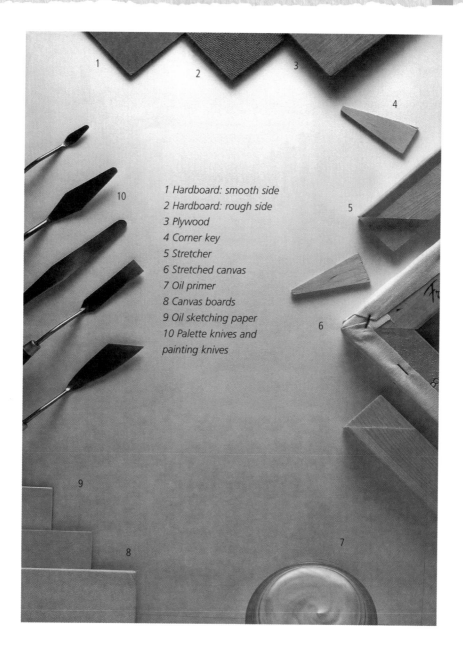

1 Hardboard: smooth side
2 Hardboard: rough side
3 Plywood
4 Corner key
5 Stretcher
6 Stretched canvas
7 Oil primer
8 Canvas boards
9 Oil sketching paper
10 Palette knives and
painting knives

Masonite, cardboard, and paper are good, cheap alternatives to stretched canvas. These must also be treated with size and primer or undercoat before use.

PAINTS

Oil paints are sold in tubes and are available in two grades, artists' and students'. Artists' colors are better quality, and this is reflected in the price. Beginners often start off with the cheaper variety, changing to the better grade as they become more proficient. Some pigments used in the paint are less permanent than others. Tubes of paint are usually graded—the more permanent colors being the most expensive.

OIL MEDIA

Oil paint is made from pigment mixed with a binder. Color can be used thickly, from the tube, or diluted with turpentine or mineral spirit. Genuine turpentine is best, although the cheaper mineral spirit, or turpentine substitute, is often used.

Used on its own, turpentine produces a matte finish and accelerates the drying time of the paint. However, the paint surface can become dull and lifeless if too much is added, and for this reason it is generally used in conjunction with an oil medium which lends texture and body to the paint. The most common of these is linseed oil. This is usually mixed with the turpentine in a ratio of 60:40. For a thicker consistency, which dries more quickly, add a little varnish.

BRUSHES

Aim for a selection of good-quality brushes. The stiff ones are made from hog hair, softer ones from sable or squirrel. An increasing selection of synthetic brushes is available. These are usually cheaper than natural bristles.

Brushes come in a variety of shapes. The basic ones are round, bright, filbert, and flat. Brights and flats are similar, but flats have longer bristles and are especially good for long, tapering strokes; rounds are good, general-purpose brushes, and a wide range of sizes of this type is useful. Filberts are flattened with slightly rounded ends to produce more controlled strokes.

There are several "specialist" brushes on the market which can be used to obtain a variety of painted effects. Of these, the fan brush is probably the most common.

PALETTES

Oil-painting palettes are traditionally made of wood. These should be treated with linseed oil before use. Disposable palettes are also available.

PAINTING AND PALETTE KNIVES

Palette knives are long and flexible, and can be used for cleaning the palette and mixing paint as well as applying it to the painting. Painting knives are specifically designed for laying paint on the support, usually to achieve a thickly impastoed effect.

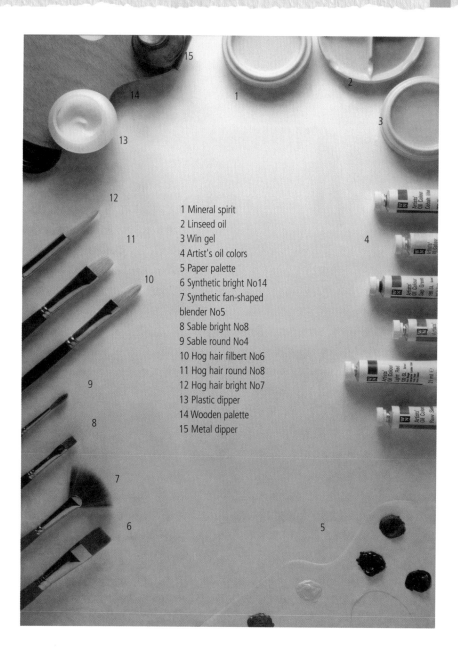

1 Mineral spirit
2 Linseed oil
3 Win gel
4 Artist's oil colors
5 Paper palette
6 Synthetic bright No14
7 Synthetic fan-shaped
blender No5
8 Sable bright No8
9 Sable round No4
10 Hog hair filbert No6
11 Hog hair round No8
12 Hog hair bright No7
13 Plastic dipper
14 Wooden palette
15 Metal dipper

What does the term "fat over lean" mean?

Lean is the term used to describe oil color that has little or no added oil. The term "fat over lean" refers to the traditional method of using "lean" color (paint thinned with turpentine or mineral spirit) in the early stages of a painting and working over this with "fat," or oil paint, as the painting progresses.

If you work in thin rather than thick washes of color, there is less danger of building up the paint surface too quickly. It is easier to correct and revise thin layers of paint than thick layers. Work in light-dark and warm-cool tones and keep the palette as simple as possible.

In this example, the artist here used a minimum of colors, with the addition of white, to successfully capture the subject of the portrait.

1 With a No4 sable brush and a wash of turpentine and burnt umber, block in outlines, facial features, and start of the background.

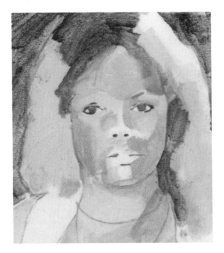

2 With a No6 bristle brush, block in the hair in gold ocher and background in thinned umber. Use burnt sienna and white for the face tones.

ARTIST'S TIP

The key to a successful portrait is to make sure that the preliminary drawing is as accurate as possible. If the features are not correctly positioned and described at the outset, the artist will find himself repeatedly laying down paint, scraping it off, and reworking in an attempt to correct the original drawing.

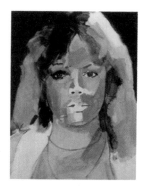

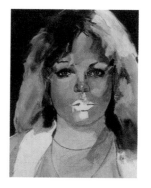

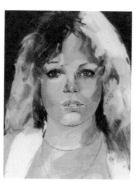

3 Mix a deeper shade of burnt umber and paint over background. Work into the hair. With burnt sienna and white, put in shadow areas on right.

4 Put in lips with a cadmium red and white mixture. Put in touches of dark shadow with the sable brush and burnt umber.

5 With pure cadmium red, paint in the necklace. Mix warmish tones of burnt sienna, red, and white and work over the face, blending in the paint.

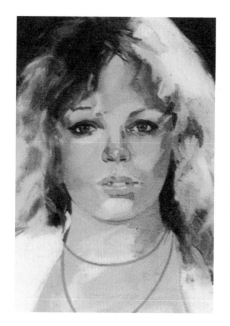

6 With a mixture of burnt umber and white, re-define the facial planes with even strokes. Mix white, cadmium green, and yellow ocher and cover in the background.

ARTIST'S TIP

To blend oil paint areas together, apply the paint thinly using the side of the brush to drag or scrub (scumble) the wet oil color across a dry surface. This method could work well in background areas of the portrait or to create textured surfaces. Blending thicker oil paint will be more successful if you follow the direction of the form with the first tonal paint strokes, then blend across the edges of the two areas with short strokes in the opposite direction. Finally, soften the blended edge with a fairly dry brush in the same direction as the first strokes.

What is impasto?

Impasto is the thick application of paint or pastel to the picture surface in order to create texture. Painting knives and palette knives are especially useful for applying thick, impastoed color to create a lively and spontaneous paint surface.

Right: *Here the artist used a painting knife to lay in the pink blouse and background area. Acrylics lend themselves to this approach, being quick-drying and therefore ideal for direct, immediate color application which requires no further working on the canvas.*

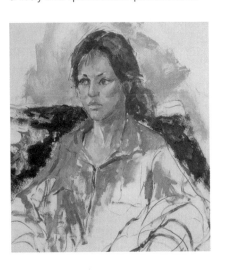

> **ARTIST'S TIP**
>
> The more often you apply thick oil paint to the surface of the canvas, even over previously dried paint, the more textural or three-dimensional the paint will appear. Vincent van Gogh and Lucien Freud both used impasto techniques to give a sculptural quality to their subjects.

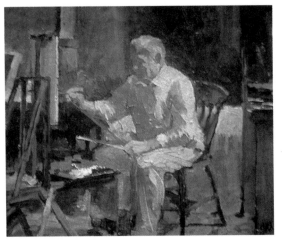

Left: *Rachel Hemming Bray, George Sweet Painting (oil on gesso on board). Rachel made the gesso ground for this painting and coated it with rabbit skin glue to decrease the absorbency. The picture was painted while George was at work and took five sittings. Rachel reworked his position, hence the thickly applied paint.*

What is blending?

Blending is the technique where colors are merged together in such a way that

the joins are imperceptible. Here it is used to add detail to a hairline.

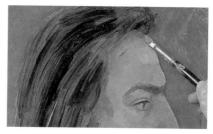

Above: *In this portrait, cobalt blue is blended into the flesh tint in the shadow areas under the beard and close to the hairline.*

Above: *Another area requiring subtlety is the hairline. Blend the forehead into hair using the flesh tint plus raw umber.*

What is scumbling?

Scumbling is scrubbing a dryish layer of paint over a previously painted area. The paint tends to skip over the surface and leave small patches of the underlying color showing through. Scumbling can be used to add texture or color to an area. It can be used with oil or acrylic.

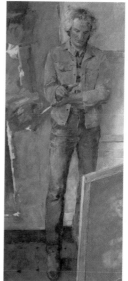

Left: *Linda Atherton, Moving Pictures (oil on canvas). In the background of this painting, you can see that the artist has scumbled paint over a toned surface but left some of the original color showing through.*

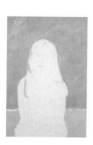

Left: *The artist scumbled lighter paint over the darker background to start to build up the tone. The texture was modified as the artist worked, but retained a lively surface.*

How could I paint a small portrait study in oil?

The challenge here is to reduce this strong and colorful subject to a miniature portrait. This artist normally works slowly on a much larger scale, and here she was required to produce a tiny portrait comparatively quickly.

All the flesh tints are mixed from these basic colors: yellow ocher, alizarin crimson, titanium white, violet, terre verte, ultramarine, cobalt blue, naples yellow, and cerulean blue paints.

For a palette, the artist used a piece of cardboard, which absorbed some of the oil from the paints, helping the colors to dry faster between applications and therefore speeding up the whole process. This artist prefers a matte finish, and getting rid of some of the oil also helped her to achieve this.

Sable brushes—which are mostly usually used for watercolors—enabled the artist to paint in the tiny, intricate strokes necessary for a miniature portrait. She managed to translate her normal bold style into the smaller format, bringing out the bright earthiness of the girl's headgear and the glow of her skin.

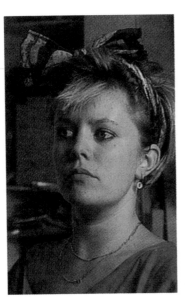

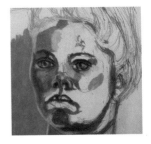

Left: *The artist referred to the subject constantly as she worked, exaggerating both the local and reflected colors found in the face.*

1 Working over a pencil drawing, the artist begins to block in the flesh tones. Define each plane clearly, treating the colors and tones as separate elements of the whole face.

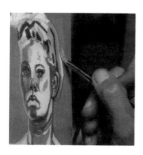

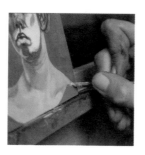

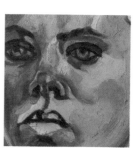

2 Establish a small area of light blue behind the head. This is an approximate color of the eventual background and will help you to mix the correct flesh tones by relating them to it. Apply cool, dark tones to the shaded parts of the neck.

3 Lighten Rowney rose with white to make the bright pink of the blouse. Apply this as a solid flat shape. Take the thick paint up to and over the flesh color to form a sharp edge.

4 The painting so far shows the partially established facial tones against the final background. To offset the distorting effect of unpainted white canvas, break up these areas with dabs of tone and local color.

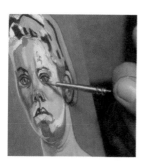

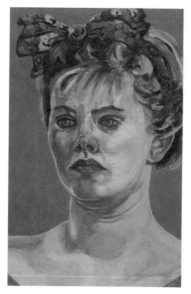

5 Moving back to the face, continue to block in the flesh tones. Use bright pink around the eye to reflect the Rowney rose and white of the blouse.

6 Exaggerate the brightness of the real colors by painting in the patterned scarf. Each of these colors is a key color in the various flesh mixtures, and the vividly depicted head scarf has a "lifting" effect on the whole portrait by bringing out and heightening the important skin colors.

How can I correct an area of my oil painting?

Oil paint can be scraped off the surface with a painting knife—many times if necessary. The area can then be over painted with fresh color. Alternatively, if the paint surface becomes too wet to work on, a piece of newspaper or absorbent towel can be laid over it, lightly pressed, and lifted off. Be sure not to press too hard or to move the paper or towel on the surface.

How can I paint an oil portrait using an *imprimatura*?

The *imprimatura*—a word used to describe the tinting of a white ground prior to painting—simply involves rubbing or brushing a very thin layer of transparent color over the white ground. Traditionally raw umber, burnt umber, or terre verte were used. Having painted the imprimatura, not forgetting to keep it very thin, it should be allowed to dry for a few days. In the example shown opposite, note that the underpainting is still visible in step 3.

 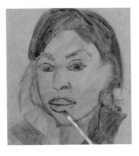 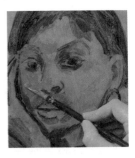

1 Work the imprimatura in two layers: cadmium scarlet then a mixture of raw umber and white. Underpaint with magenta thinned with turpentine, then block in the head and hand.

2 Add monestial turquoise to the magenta, block in dark areas, and establish a likeness. Keep the paint thin so that it can be moved around easily.

3 Block in the half tones next. Mix a flesh tint using cadmium orange, cobalt green, Indian red, and white. Block in background; strengthen hair, eyes, and eyebrows with sepia.

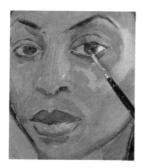 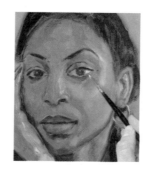 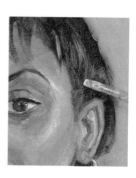

4 Darken the upper lip with a mixture of Mars violet and sepia. Add highlights using cobalt green and white, with cerulean blue on the cheek bone, nose, and upper and lower lip. Develop the eyes using Indian red on the iris and cerulean blue and white for the whites.

5 Add highlights with titanium white warmed up with a little lemon yellow.

6 Use ivory black and sepia to pull the fringe forward over the forehead and complete the hair.

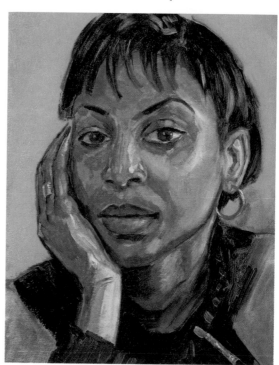

7 Finally, add a few textural details with sepia, black, and white.

How can I paint the planes of light and shade in the face piece-by-piece?

In this example, the artist sketched in the outline of the head with willow charcoal to establish the broad form. Charcoal is a good medium for this initial work, because it is rough and immediate, and thus prevents any over-attention to small detail, irrelevant in the early stages. She then quickly worked over the charcoal outline with a B pencil, developing the drawing and making a more specific outline, after which the surface was wiped to remove excess charcoal dust.

1 Working on a piece of primed Masonite, start by drawing the subject with willow charcoal.

2 Block in the background and head scarf. Begin the face, starting at the eye and working outward.

3 Fill in planes of light and shade piece by piece. Paint each tone as a flat plane of color.

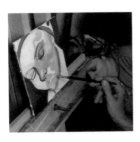

4 Add small shapes of flesh tone. The image emerges gradually as each patch is filled in.

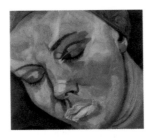

5 Shaded areas are mainly cool, light areas are mainly warm. Paint shadows around the nose with a dark purple.

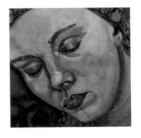

6 The woman's head slants diagonally across the picture, yet seems also to fill it, so that the diagonal does not intrude too much.

How can I paint darker skin tones?

Capturing the variety of tones and colors in a face is an interesting task. The local facial color of people of different races can be different, but light and shade largely determine the tone. For all skin tones, the local color determines the basic tone to a degree, but the strength and direction of the light falling on the facial planes creates the color variations. For this portrait, the artist has drawn out the shapes of the tonal planes in pencil, and filled them in as areas of flat color. The slow-drying quality of oil paint enabled these to be blended together to give the impression of soft, rounded forms. (*See also pages 68, 74, and 208.*)

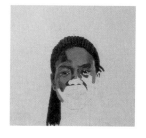

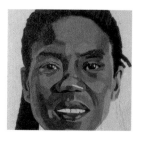

1 Draw the outline of the subject with a well-sharpened F pencil, indicating the areas of light and shade.

2 Paint the hair. Start to block in the skin tones. By working from the top down, you can avoid smudging the wet paint.

3 The planes of light and shade on the face meet and overlap in carefully observed, natural shapes.

4 Block in the background. Apply color as evenly as possible. Preserve the irregular, complex shape of the hairline.

5 Paint the T-shirt. Indicate the shadows with gray.

6 Rather than add a shadow behind the girl, maintain the simplicity of the painting by brightening the T-shirt.

How does the canvas surface affect the look of the finished painting?

The quality of different canvases varies considerably. They are usually available in materials such as cotton, linen, hemp and hessian, and in different weights. The important thing is that the weave is close and free of knots and flaws. A canvas may be chosen for the size of its weave, for its roughness or smoothness, for its imperviousness, or for the way it absorbs the paint. Canvases are made from linen, cotton, a linen-cotton mix, and hessian. (*See also page 152.*)

Unbleached calico is a cheap cotton weave.

A good-quality cotton canvas feels as fine as linen when it is well-primed.

Hessian is coarse and needs effective priming if a smooth effect is required.

Linen is generally available in several sizes of weave.

The most expensive linen is closely woven.

Linen primed with acrylic is multi-purpose.

How can the background be changed during the painting of the portrait?

The use of oil paint for this portrait enabled the artist to build up layers of paint gradually, incorporating both thick and thin paint. During the early stages of the painting, the figure was positioned against a simple, uniformly colored backdrop; later on, it was felt that the introduction of another image might accentuate the main subject's pose. A second figure was introduced, into the background, echoing the leaning posture of the subject.

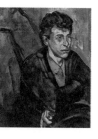

1 Use a limited range of colors to establish the position of the figure and chair using paint thinned with turpentine.

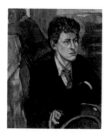

2 Block in the background in red and add basic skin tones in the face.

Above: *The subject sits astride a chair. This implies alertness and tension rather than a more conventional, passive pose.*

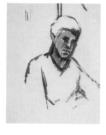

3 Begin to define the features and add more detail to the skin tones.

4 Overpaint background and continue to adjust skin tones and features.

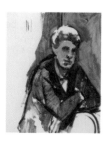

5 Add a second figure in the background, but paint it simply and flat.

How can I use glazing to build up skin tones?

By using glazes you can avoid using wedges of opaque color for patches of light and shade. Flesh does not consist of a patchwork of tones and colors—it is more subtle than that. Visually, it is made up of overlapping veils of translucent color. By using glazing, a natural transition from light to dark, from cool to warm, or vice versa, becomes possible.

In this example, the girl's profile, standing out strongly against a dark, flat background, provides the opportunity for the use of space as a "negative shape" (see page 46). The artist has done this deliberately, by cutting off the top and the back of the head, resulting in two interlocking shapes—the head and the space into which it faces.

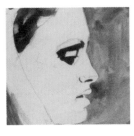

1 Use a thin wash of burnt umber and turpentine to block in the shadow areas. Build up the glazes gradually.

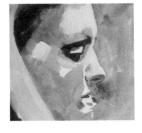

2 Loosely block in the warm facial tones and the light hair color.

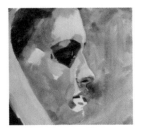

3 Paint the shadows around the eyes with black, white, and a touch of burnt umber.

4 Work into the skin tones, developing the planes of light and shade.

5 Apply each small area of warm highlight and cool shadow carefully in thin layers.

6 Apply the background. Use a large brush to obtain a flat, even expanse of color.

How could I paint a self-portrait in oil?

An artist is often his or her own best model. Most of the great artists have painted self-portraits during their career.

Setting up a self-portrait is important. Make sure that you have a mirror in which you can easily see yourself without twisting or stretching. You should be able to look from the canvas to the mirror merely by shifting your gaze. Ensure that you have an adequate light source—artificial or natural. The light should be sufficient to see by and add interest to the painting. Make sure that you can reach all your materials and mark the position of the easel, mirror, and your feet so that when you step back you will be able to resume the position and pose again.

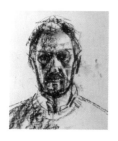

1 Use charcoal to establish the broad outlines. Re-establish the lines by tracing over them with paint.

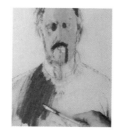

2 Mix flesh tints and, with thin paint, start to block in main tonal areas. Peer at your image through half-closed eyes.

3 Lay in a dark tone for the hair. Start to block in the broad areas of color of the clothing.

4 Return to the subject at regular intervals. Use a long-handled brush so you can work at a distance.

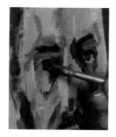

5 Consider the details: the eyes, nose, and mouth. Study your face carefully and put down what you see.

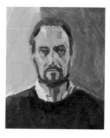

6 Add darker tone to increase the depth of the shadows and subtle tone to complete the shape of the face.

How can I start an oil painting with an acrylic underpainting?

Although some painters favor working "wet-into-wet," there are many advantages to making an underpainting. An acrylic underpainting, in particular, may be useful as a means of establishing the image prior to the application of oil. In this portrait, the dominant color is red; by painting the background first in green, the complementary of red, and then applying red, the final color has an added vibrancy. Much of the figure is also underpainted in green, in anticipation of the warm skin tones to follow.

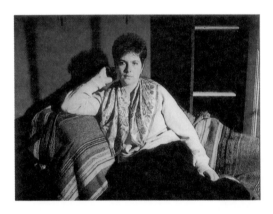

Left: The chaise-lounge allows the model to pose more naturally than would be possible in a straight-backed chair. A red folding screen is chosen for the background; its uniform color will dominate the tones of the painting and the simple vertical divisions form an important compositional structure. The spotlight situated to the right of the model lends an element of drama.

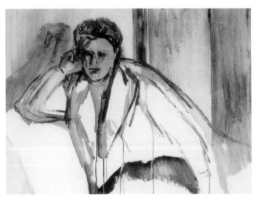

1 Use washes of green-blue acrylic paint to rough out the basic structure of the painting, paying little attention to detail but considering the overall design in terms of the abstract relationship of one form to another.

2 Mix lighter shades of green on the palette. Apply these primarily to the face, establishing mid-tones and areas of highlight.

ARTIST'S TIP

For an especially thick, textural effect, mix acrylic paint with modeling or texture paste. It is thicker than paint and transforms the color into a stiff substance which retains the shape of the knife.

3 The quick-drying property of acrylic paint makes it ideally suited for underpainting; subsequent layers of oil can be applied without hindrance.

4 Gradually indicate more information about the volume of the form. Leave the underpainting to dry. The next stage is to begin painting in oil. Apply the skin tones thinly at first to allow the underpainting to show through.

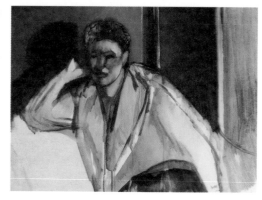

What materials are needed for acrylic painting?

Compared with oil and watercolor, acrylic is a very new medium. Its main advantage is that it is harder and more permanent than traditional media. It is also highly resilient and resistant to atmospheric conditions, such as damp and decomposition, and once it is dry, it retains its texture and color.

SUPPORTS

Acrylic paints can be used on almost any type of surface. Canvas, Masonite, and paper are the most popular choices, although there are many more supports which are just as suitable, such as wood, plastic, metal, and various fabrics.

It is not necessary to size acrylic supports, but a special acrylic primer available from artists' suppliers is normally used. Under no circumstances should oil grounds and primers be used; ordinary emulsion grounds are not usually compatible with acrylics. Commercially prepared surfaces— canvas, boards, and paper—are available, but make sure they have been treated for acrylics and not for oils.

There are several cheaper alternatives to bought surfaces. As with oils, you can use paper, cardboard, and canvas, treated with the appropriate acrylic primer. Cheap paper will probably wrinkle if you use the paint diluted, so use a good quality thick one. You can also stretch your own canvas (*see page 152*) and give it two or three coats of acrylic primer. Many artists use dilute acrylic directly on raw, unprimed canvas to obtain the luminous wash effect known as "staining."

PAINTS

These have technical names such as dioxazine purple and naphthol crimson which reflect their laboratory origins. The thickness of the paint depends on the brand, but the consistency is generally similar to that of gouache or oils. PVA colors are cheaper than acrylics and are made with less costly pigments, although they share the hardwearing and quick-drying advantages. Cheap vinyl colors are sold in larger quantities, especially for use on big areas. Alkyds are acrylic-based paints which are mixed with turpentine instead of water.

You are not confined to using acrylics by themselves. They are particularly good mixers and can be combined effectively with other materials. They are popular for collage work. One characteristic of acrylics, which makes them ideal for collage, is their adhesiveness—you can stick a shape or cut-out into wet acrylic paint or acrylic medium.

1 Palette knives
2 Liquitex paint
3 Synthetic fan-shaped
blender No4
4 Hog hair flat No8
5 Hog hair round No3
6 Synthetic bright No6
7 Synthetic round No11
8 Sable round No8
9 Flow formula acrylic paint

BRUSHES

Brushes suitable for oil or watercolor are generally also suitable for acrylics, but you may develop a different way of working, which will call for different brushes. Acquire a few useful shapes and sizes, adding to these gradually as you discover what your specific needs are.

Oil painting brushes are normally made of bristle, whereas the best watercolor brushes are sable. Both types can be used for acrylics, but the bristle brushes, which are stiffer, are generally more appropriate when the paint is applied thickly in the manner associated with oil paint. Soft watercolor brushes are usually preferred for more translucent, diluted paint effects.

All brush types are now available in nylon. These are hardwearing, and many artists find the synthetic brushes particularly compatible with synthetic acrylic paint. It is easier to remove acrylic paint from nylon brushes, but, like all brushes, they must be cleaned well and frequently, since acrylic paint dries so fast that they can become stiff and unusable very quickly. The large nylon brushes sold in hardware and decorator's stores are excellent for applying large areas of flat color.

MEDIA

Acrylics are not compatible with the media used for oil paint. You can buy various substances which can be mixed with the paint to achieve different effects and, of course, the paints can also be thinned with water. Gloss and matte media—as their names suggest—can be added to make the paint surface dull or shiny, and there is a particularly useful medium called retarder, made of glycerine, which slows down the drying of the paint, thus giving you more time to correct the image, manipulate the paint, and adjust the tones.

For creating prominent, textured brush strokes, use gel medium, which comes in a tube and is thicker than the paint itself. If you want to make your colors really thick, mix the paint with texture or modeling paste. This can be built up on the surface of the support to form a heavy impasto, and is particularly effective when applied with a palette or painting knife.

OTHER EQUIPMENT

There is generally little difference between the equipment used with acrylic and that used with oil or watercolor. However, it is better to obtain a white, plastic palette because it is easier to clean acrylic paint from a plastic surface.

If you find the quick-drying color hard to handle, there is a special palette which is designed to help, the Rowney "Staywet" palette, which uses the principle of osmosis to keep colors wet for several days. You can also keep the paint wet on your palette by occasionally sprinkling it with water or spraying with water from an atomizer.

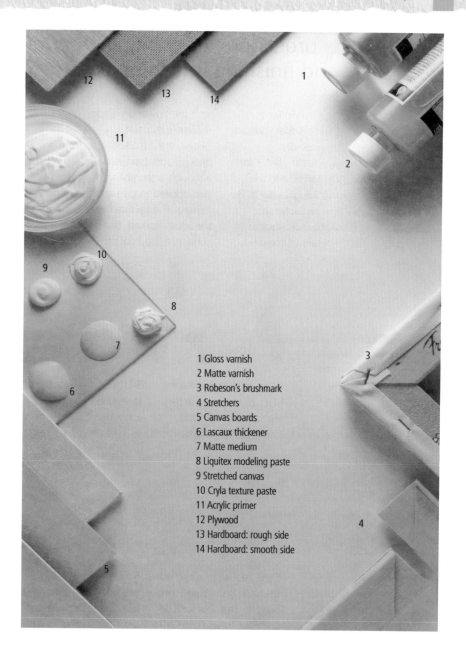

1 Gloss varnish
2 Matte varnish
3 Robeson's brushmark
4 Stretchers
5 Canvas boards
6 Lascaux thickener
7 Matte medium
8 Liquitex modeling paste
9 Stretched canvas
10 Cryla texture paste
11 Acrylic primer
12 Plywood
13 Hardboard: rough side
14 Hardboard: smooth side

What is the procedure for painting a portrait in acrylic and finishing it with oil paint?

The advantage of using acrylic for the background of a painting is that you can take advantage of its quick-drying property. Here, the artist also used it for the hair, the basic skin tones, and the large blue expanses of the girl's dress. He then developed the more subtle skin tones, some parts of the face, such as the mouth, and the details of the dress, with the slower-drying and more malleable oil paint.

Here, the artist toned down the background, painting it in neutral colors, although a scumbling of lighter color was applied to give an interesting texture. The texture became modified as the artist worked, but still retains a lively surface in the final picture.

1 Working on pre-primed canvas, make a detailed drawing using an F pencil. Paint the background area.

2 Start to block-in the skin tones. By working from the top down, you will avoid smudging the wet paint.

3 Establish the basic overall tones with a series of flat acrylic colors. Do not attempt to blend the areas of color.

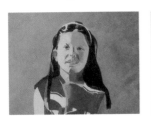

4 Start to work in oil paint, building up the facial details.

5 Use masking tape to create straight edges of brown band along the seat. Remove it carefully. (*See also page 179.*)

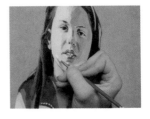

6 Continue to develop the tone and detail, improving the form and adding increased depth to the image.

How can I make a complete portrait painting in acrylic?

The properties of acrylic paint enable the artist to alter a painting to a greater extent than would be possible even with oils. If you feel that the picture has begun badly, you can reconsider the composition, pose, tonal structure, and scale. Acrylic is not water soluble once it has dried—subsequent layers will not disturb the paint beneath and this application technique is similar to oil.

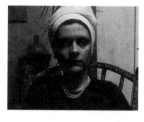

1 The model was originally wearing a dark dress and turban. Later, the artist felt that more time and space should be devoted to the head and less to the background.

2 The original pose lay-in can still be seen behind the new drawing.

3 Tone in the canvas in thin washes. The original painting becomes part of the underpainting for the second image.

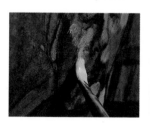

4 Apply flesh tones using fairly thick paint. The grain of the canvas breaks the paint stroke.

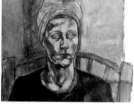

5 The flesh tones and background serve to lighten the picture. Apply each color on the face as a separate patch. Apply finishing touches in white.

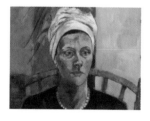

6 Last minute additions of the fern and pearl necklace provide points of focus.

How can I mask out shapes in an acrylic painting?

For foliage and other complicated and repeated shapes, crisply defined edges can be effective. They can be made using masking tape.

1 Here the artist has selected a few leaves, giving them a clean, cut-out edge which "lifts" the otherwise flat mass of foliage, creating the illusion that all the leaves are more finished than they actually are.

2 Wide masking tape is used, and the leaf shapes are cut out with a craft knife. The tape is pressed firmly into position and the thickish light green paint applied with a bristle brush. The tape is removed when the paint is dry.

ARTIST'S TIP

Masking fluid or frisket can be used with acrylic washes to save color areas either at the beginning or throughout the painting. The acrylic paint must be dry first and then the masking fluid must also be completely dry before you paint over it. Don't paint too thickly on top of the frisket or you will have to scrape the paint away to remove it. The frisket can then be removed by rubbing with your finger, or for larger areas, with a rubber cement pick-up tool.

How can I use flat shapes of tone to show form?

Flat patches of color can be systematically built up to create a solid, convincing form.

Left: *The objects in this detail form a miniature still life within the main painting. This adds an unusual touch without drawing attention from the subject. The colorless nature of the wine glass is suggested by the use of distorted shapes of the background colors; the rounded shape of the glass is indicated by the use of well-observed shapes of flat tone.*

How can I paint straight lines in acrylic?

You can use masking tape (*see opposite page*) or a plastic ruler. To paint continuous, even lines using a plastic ruler, it is necessary to mix the paint to a thin, runny consistency. Here the artist uses a No6 synthetic brush, holding the ruler off the surface of the painting. But be careful, if the loaded brush comes into contact with the edge of the ruler while the ruler is resting on the support, the paint will form blobs and run underneath.

Left: *Using a plastic ruler, the artist carefully paints five lines into the background of the painting.*

How can I paint an acrylic portrait on paper?

In this portrait, the artist shows how to work boldly with acrylics on paper. Follow the steps to learn how to put one layer of color over another, correcting where necessary, and achieve an energetic and fresh finish.

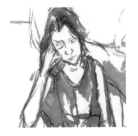

1 Draw in the composition using cerulean blue thinned with water. You can work broadly and confidently here as mistakes can be overpainted.

2 Reaffirm the drawing with a reddish-brown red hue. Begin to work in the main color areas around the figure using permanent hooker's green, deep hue, and titanium white.

3 Fill in the head and arms with dilute quinacridone red. Use a bright lemon yellow for the chair. The paper is now almost covered with a thin layer of paint.

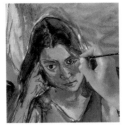

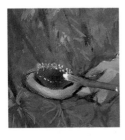

4 Brush a thin layer of lemon yellow over the red face and arms. Add shadows to the face; emphasize the tonal contrast between the pale face and the dark hair.

5 For the eyes, use permanent Hooker's green deep, mixed with parchment for the lighter tints on top of deep violet and reddish brown. The dress is completed next.

6 Tone down the background. The hairbrush is completed last, the final touch of titanium white being applied with the tip of the paint brush. (*For finished portrait see page 56.*)

Are there more examples of acrylic portraits painted on paper?

Acrylic can be applied thickly for rich impastos, or very diluted to obtain transparent washes. But although the results sometimes resemble oil or watercolor, it is a mistake to regard it as a substitute for either. Acrylic is a medium in its own right, very different from any other, and patience and practice are required to get the best results whatever surface you choose to paint on.

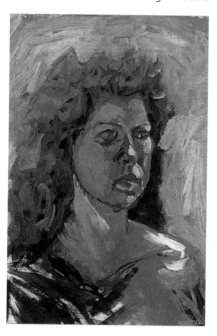

Above: *David Cuthbert, Ione (acrylic on paper). David began with thin washes and then worked with thicker paint straight from the tube, using large hog brushes and working with great speed and verve to achieve this energetic portrait.*

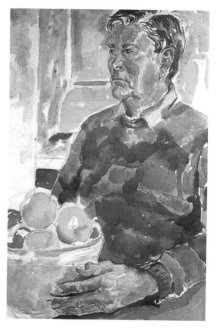

Above: *Stina Harris, Sam Falle (acrylics on paper). This study of the artist's father shows how acrylic can be laid on in transparent washes and worked wet-into-wet as with watercolors. Stina first drew with red brown crayon and then worked swiftly, thinning the paint with plenty of water.*

How can I blend skin tones in acrylic paint?

Acrylic paint can be used in very thin washes similar to watercolor, when even the opaque pigments are used thinly enough to make them seem transparent, or at least translucent.

It can also be built up thickly and with the addition of impasto medium, worked in impasto techniques. It can also be used with transparent gel medium for glazing, a technique familiar to most oil painters. Its quick drying properties might make it a tricky medium for portraiture if you like to spend time blending colors together. But it can be mixed with a retarding medium to slow up the drying, giving time to work fresh paint into a wet surface, essential for some portraiture where it is important the "joins" in layers of paint should not be visible.

Right: *The artist used acrylic paints on paper to make a quick, but detailed, study. Brush strokes created the form of the arm and fabric texture. The colors are muted but warm and glowing. Areas of neutral brown are enlivened with touches of green and dark red in the shadows. The effect of bright, artificial light is enhanced by a cast of yellow in the highlights.*

How can the figure be modeled with warm and cool tones in acrylic?

This painting develops as a series of steps in which the artist modeled the figure out of warm and cool tones, constantly watching their effect on one another and on the painting as a whole. Using a thin wash, a warm tone for the flesh would be put down and then overlaid with a cooler, lighter shade. Outlines and feature details would then be reinforced, and the process would begin again.

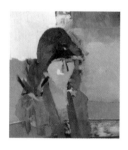

1 Using a thin wash, block in main color areas with pthalo crimson, burnt sienna, yellow ocher, white, and cerulean blue.

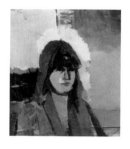

2 With burnt umber, define dark areas and draw in the features. Block in shadow areas behind head and light area.

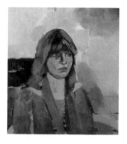

3 Highlight flesh with a mix of yellow ocher and white. Combine yellow ocher and red to highlight hair.

4 Mix a pale tone of white and pthalo violet and block in the background with large strokes, blending the paint well into the surface.

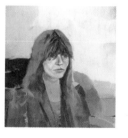

5 When dry, work back over face, glazing in strong highlight areas with a thin wash of white and water.

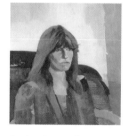

6 Mix white, yellow ocher, and a little red for warm areas of the face. Mix pthalo violet and white and rework background.

PASTEL, WATERCOLOR, AND GOUACHE

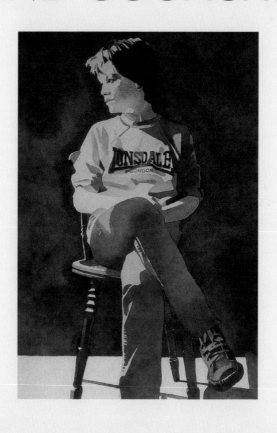

What are the materials needed to paint in pastel?

Pastels lie half-way between painting and drawing. Traditional pastels are soft and chalky, requiring care both during the execution of the work and afterward, when it is easy to smudge them. They have qualities in common with chalk and conté crayon, which are sometimes included in the same category.

SUPPORTS

The most important consideration when choosing paper for pastels is the texture. This must be rough enough to provide a "key" or "tooth" for the fine pastel dust to adhere to; otherwise the color literally drops off the paper.

Papers that are specially made for pastels have a velvety or sandpaper-like surface. This allows a substantial amount of color to be built up. Good quality drawing or watercolor paper is perfectly adequate, provided it is coarse enough to take the pastel. Very smooth surfaces are almost always unsuitable, since the pastel slips around the surface and very little color will adhere to it.

Tinted papers are excellent for use with pastels. Warm, cool, bright, or subtle shades can be exploited to advantage. The tinted paper is allowed to show through between the pastel marks, integrating the composition and contributing to the work in a positive and effective way. Some artists tint their own paper for pastel work. To do this, dip a dampened rag in the crushed ends of pastel sticks and rub on the paper to produce a toned background.

Prepared canvas or "scrim," a thin muslin-type cloth glued to a board or piece of cardboard, is often used.

SOFT PASTELS

Soft pastels are powdered pigments mixed with enough gum arabic or resin to bind them together. The word pastel, now widely accepted as meaning anything which is pale or mixed with white, comes from the "paste" of pigment and gum which is molded into the solid sticks and sold either individually or as boxed sets. One set is sold especially for portrait work.

A reasonable choice of colors is essential, since pastels can only be blended to a degree. Overblending results in loss of brilliance and a clogged paper surface, both of which deaden the natural freshness and spontaneity associated with the medium.

An organized, systematic approach is essential. Each color comes in a selection of tones, from very light to dark, and if you cannot immediately lay your hands on the one you want, you will end up using the wrong tone.

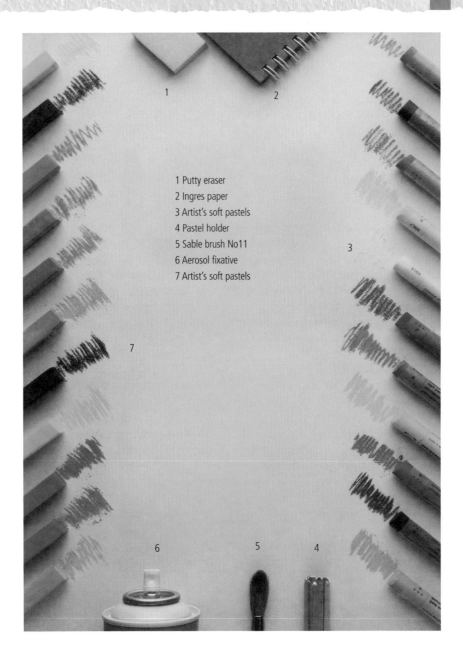

1 Putty eraser
2 Ingres paper
3 Artist's soft pastels
4 Pastel holder
5 Sable brush No11
6 Aerosol fixative
7 Artist's soft pastels

OIL PASTELS

In this type of pastel, the pigment and chalk are mixed with oil instead of gum arabic. Oil pastels are more stable than the traditional soft pastels, being harder and less easy to smudge. They are particularly good for sketching, where a strong, colorful image is required, and they can also be used in conjunction with oil paints, either for the initial drawing or for rendering final details.

Oil pastels are not easy to blend by using one color over another, since they tend to clog in an uneven mass, but they can sometimes be merged by rubbing. They are soluble in turpentine, and this can be applied directly to the support with a rag or brush to produce a smoothly blended effect.

CARE OF PASTELS

Too much pressure causes soft pastels to break, and you can end up with a mass of small pieces, most of which are not large enough to hold or manipulate. This situation is much easier to salvage if your set is kept systematically in the box, since larger broken pieces can be put back in their original place without getting lost.

FIXATIVE

Soft pastels must be fixed or the picture will become smudged and ruined. The soft, powdery nature of the medium makes it particularly vulnerable, and even pastel drawings framed under glass will disintegrate to some degree without fixing. The fixative is sprayed onto the finished work and binds the loose particles of pigment to the ground (see page 149).

Various adhesive materials have been used as a fixative—in emergencies some artists have used hair spray. Fixative can be bought ready-made in convenient aerosol cans, or it can be bought in bottles, in which case you will need a mouth spray, or atomizer, to apply it.

Fix the work by holding the spray about 12 in (30 cm) away from the drawing, which must be held vertically. Apply the fixative lightly from side to side across the entire surface. Several light coats are better than one heavy one, for a soaking may cause colors to run and affect the crispness of the image. Pastels can be fixed from the back as well as the front, depending on the drawing and the amount of pigment on the surface. You can also use fixative lightly after each stage, although too much will cause the surface to become shiny and unreceptive to more pigment.

OTHER EQUIPMENT

A chamois stick and a tortillon or torchon (a pencil-shaped stump usually made from tightly rolled paper) (see page 147) are useful for blending and rubbing out. Pastel holders can be helpful for holding short sticks and for keeping your hands clean. For sharpening pastel sticks, use sandpaper; and for erasing lightly-worked areas, use a kneaded eraser.

1 Turpentine
2 Torchons
3 Oil pastels
4 Tinted papers
5 Oil pastels

Why is the choice of paper particularly important with pastels?

Toned paper can be used in pastel painting in a similar way to an *imprimatura* in oil painting (*see pages 81 and 162*). It can be allowed to show, or left uncovered as part of the final image.

Choice of paper is important with pastels—darker and tinted papers are often used, since they provide a ready-made tone against which the other colors can be set. When using white papers, remember that whatever color goes on them will show up darker than the background, and the flat plane of white paper has to be counteracted with the pastel. Areas of white showing between pastel strokes tend to "fight with" a solid form.

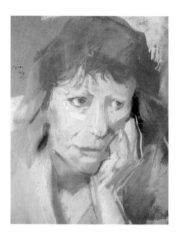

Above: *The light brown paper is used in this sketch as part of the background and also as a shadow color within the face.*

How can I make solid areas of color with strokes of pastel?

Pure, dense color can be built up by using tightly packed, regular strokes of pastel. Here, the artist develops the face with strong, warm tones, keeping the strokes close and parallel to produce an area of solid color. The tinted paper has been virtually obliterated by the marks.

Right: *The strokes of pure color are not blended, so that each new color stands separately from those already applied. For every strong, dense color, such as the highlights on the hair and face, the artist applies considerable pressure while drawing.*

How can I use pastels so that the color mixes optically?

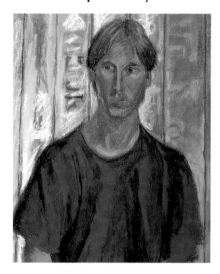

Pastel colors can be blended by rubbing them together, usually with cloth, tissue, or the fingers. Or they can be blended optically, to mix in the eye of the viewer rather than being actually blended together on the support (*see page 84*).

Left: *The colors were blocked in before being carefully modeled to give the face shape and character. Soft touches of charcoal were used to give a soft, dark line in the eyes.*

How do I blend colors in pastel?

You can use your hand and fingers to blend colors. Take care not to over do it, since too much blending can make the image blurred and soggy. Allowing enough of the coarse pastel strokes to show through will preserve the form and structure of the subject, and provide textural contrast.

Can pastels be used as mixed media with watercolor?

Watercolor washes on watercolor or pastel paper can be used as under paintings for a pastel painting or sketch. If the paper is thin it may need to be stretched first (*see page 200*) so that it doesn't buckle. Watercolor and pastel are mediums with sharply contrasting characteristics. They can be played off against one another in a painting to achieve exciting and unusual effects.

How can I make a color sketch with pastel?

Character and expression are important in this portrait, and the artist relied on a color sketch to capture the spontaneity of the subject's smile and casual pose.

Blue-gray pastel paper, which has a greenish hue in the final result, gives an immediate fullness to the background.

The artist began with an outline in burnt sienna; the backward and forward action quickly established the main areas, bringing the image up almost as though it were emerging through a mist. Pastels can have this rapid and direct effect if used with confidence.

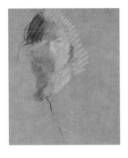

1 Draw in the outline in burnt sienna. Lay in strokes of warm and cool colors, blending them with a finger.

2 Work into the face with orange, pink, and ultramarine. Use strokes of raw umber for the hair.

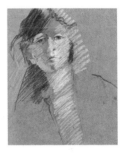

3 Use fine black lines and areas of strong color to accentuate shapes. Redraw outlines in darker tones.

4 Build up pure, dense color using tightly packed, regular strokes of pastel. Keep the strokes close and parallel.

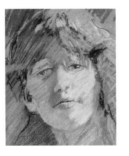

5 Draw the hand and arm with a fine black line, and then establish solid areas of pink, red, mauve, and yellow.

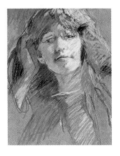

6 Lay heavy strokes of dark blue across the top of the paper to establish the background tone.

What is the process of making a pastel portrait on a dark surface?

Pastels can be used either in a linear way as a drawing medium, or in a more "painterly" way to obtain areas of solid color. The artist here has combined both approaches, using line to establish the pose and draw the main characteristics, then developing selected areas in blocks.

Dark, rich brown paper was chosen for this portrait. This enabled the artist to lay in light skin tones and the highlights of the hair with maximum effect, allowing the paper to show through and suggest shadows and recesses.

The model sits in an armchair, in a pensive pose, looking directly out of the picture. The strongest light comes from behind her left shoulder, emphasizing the shape of the back of the neck and the jawline. The background was complex, but the artist has ignored this, concentrating only on the powerful expression and mood of the pose.

1 Use white to establish the face and hands. This will be integrated into the flesh tones. Diagonal shading emphasizes the form of the head and marks key areas of light and shade.

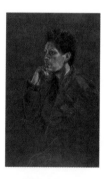

2 Begin to block in the shoulders and upper part of the jacket. Fill in local color and highlights with blue; the tinted paper shows through to indicate shadow.

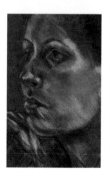

3 Make the flesh tones become more substantial. Introduce a range of strong orange-pinks and blue-greens to depict the warm highlights and cool shaded areas of the face.

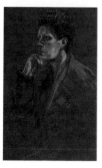

4 The warm, deep brown paper provides maximum contrast with the cold blue of the jacket. It also allows the flesh tones to be solid areas of light color. (*See also page 35.*)

What are the materials needed to paint in watercolor?

Watercolors are made from pigments mixed with gum arabic and water. These pigments may be animal, vegetable, or mineral, and their quality is reflected in the price of the paint. Most artists work with a limited range of paint, and a reasonable range of well-chosen, soft brushes is adequate for most purposes.

SUPPORTS

Watercolor paper comes in various sizes, from pocket-sized pads to very large sheets. These differ in thickness and are designated by their weight per ream (500 sheets). Imperial-size sheets, which measure about 22 x 30 in (56 x 76 cm) are used for the measuring. The lightest watercolor paper is 72 lb; the heaviest is 400 lb. The best watercolor paper comes from Europe and is sized metrically, according to the number of grams per square meter (gsm) in a ream.

Lightweight and cheap papers should always be stretched before use (see page 200). Properly stretched paper will not wrinkle, however wet your colors are. With thicker and better-quality papers, stretching is usually unnecessary.

The texture of watercolor papers is important. Some are very rough, with an irregular, "pitted" surface which is favored by many painters. Others are completely smooth.

Handmade papers are superior to those manufactured on a machine and are more expensive. To find out which is the right side—the side which has been sized—hold it up to the light and look for the watermark of the maker's name. This should be the right way around.

Machine-made papers are usually cheaper, and the better quality ones are very good indeed. They are available in three main categories: hot pressed, cold pressed (also called "not"), and rough. The hot pressed type tends to be very smooth, and is suitable only where a particularly flat finish is required. The most popular is cold pressed, and the majority of watercolor papers fall into this category. Rough paper is used when a particularly rugged effect is required.

Watercolor papers are traditionally white or off-white. Colored or tinted paper is sometimes used for gouache and other opaque paints.

PAINTS

Genuine watercolor contains no opaque ingredient which would threaten its pure, transparent quality. It is sold in pans or half-pans of moist color, cakes of dry color, tubes, and bottles of liquid color.

Dry cakes are the least expensive, but are usually inferior and require much "working" with water before yielding a

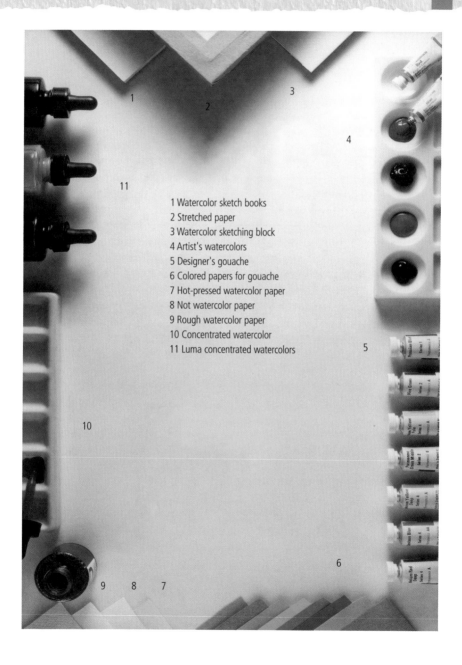

1 Watercolor sketch books
2 Stretched paper
3 Watercolor sketching block
4 Artist's watercolors
5 Designer's gouache
6 Colored papers for gouache
7 Hot-pressed watercolor paper
8 Not watercolor paper
9 Rough watercolor paper
10 Concentrated watercolor
11 Luma concentrated watercolors

strong color. Pans or tubes are the professional's choice. Liquid colors, often concentrated, come in small bottles, some of which have a dropper, allowing greater control over the strongly tinted fluid.

Gouache usually comes in tubes and, like watercolor, is available in a wide range of colors. It is an opaque medium, used for its good colors and strong covering powers. Unlike pure watercolor, gouache allows you to paint light colors over dark ones. It dries lighter than it appears when wet, with a matte, slightly pastel finish. Powder color and poster paints are occasionally used instead of gouache, but their color and texture bear little resemblance to the real thing.

There is no substitute for pure watercolor with the best quality pigments. A cheaper students' range is available, but these paints are inferior.

BRUSHES

The best watercolor brushes are made from sable, the hair of which comes from the tail of the kolinsky, a small mammal living in certain areas of Russia and China. Because of the inevitably high price of these brushes, manufacturers sell a brush which combines sable with other types of bristle—often the slightly stiffer ox hair, which comes from the ox's ears. Camelhair, squirrel, mongoose, and the many good synthetic varieties now on the market are all good alternatives.

Brushes range from the tiny No000, used for detailed retouching work, to No14 and larger. The large sizes are useful for washes and expanses of color.

The most common and the most useful watercolor brushes are the "rounds." Some brushes, known as chisel-ends, have flattened bristles, and these are also useful for applying washes. The fan-shaped brush, with its regular spread of bristles, is used for special effects and graded washes. A small decorator's brush is useful for applying large areas of color, and an ordinary toothbrush is an invaluable aid for textures and spattering effects.

PALETTES AND OTHER EQUIPMENT

Watercolor palettes are generally plastic or ceramic. Those which are incorporated in a paintbox are usually enamel. They have special recesses to hold the different colors and for mixing. Palettes with a thumbhole are especially useful for outdoor work. In the absence of a proper palette, you can use old plates, saucers, or any other suitably sized receptacle.

You will also need a drawing board to support the paper (a piece of plywood or blockboard will suffice); other useful items of equipment are a small natural sponge for blotting paint and making textures, plastic water jars with lids for outdoor work, and paper towels for drying brushes and blotting. Gum water and gum arabic are sometimes used to give body and extra sheen to the colors.

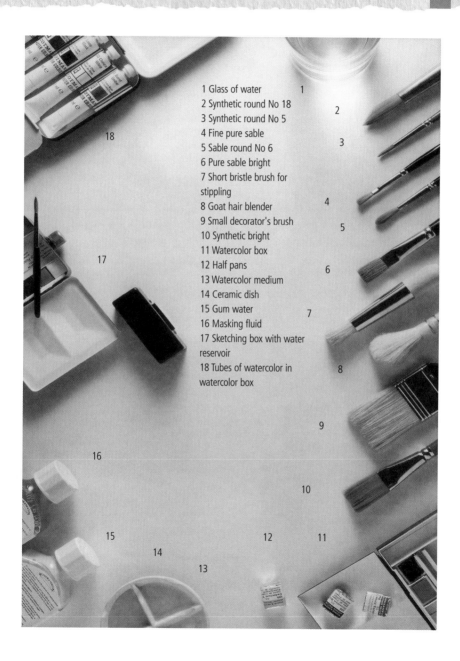

1 Glass of water
2 Synthetic round No 18
3 Synthetic round No 5
4 Fine pure sable
5 Sable round No 6
6 Pure sable bright
7 Short bristle brush for stippling
8 Goat hair blender
9 Small decorator's brush
10 Synthetic bright
11 Watercolor box
12 Half pans
13 Watercolor medium
14 Ceramic dish
15 Gum water
16 Masking fluid
17 Sketching box with water reservoir
18 Tubes of watercolor in watercolor box

How can I enlarge my photograph for a watercolor painting?

First construct a grid on a piece of tracing paper, to cover the relevant area of the photograph. Draw a similar grid, the same size as the proposed painting, on a second piece of tracing paper and enlarge the image square by square onto this. Include any details in this enlarged drawing. Place a sheet of tracing-down paper, sometimes called iron-oxide paper, face-down on the support. Place the enlarged drawing on top of this and carefully follow the lines of the drawing. The tracing-down paper acts like carbon paper, producing a light brownish image which is ready for painting.

Graphite transfer paper can also be used to transfer the enlarged drawing to watercolor paper.

What is "dry brush" in watercolor and how can it be used in a portrait?

To create a dry-brush effect, dip a brush in paint and blot on a towel or rag. Press the brush hairs between thumb and finger to spread the hairs and brush on to the surface with light, feathering strokes using only the tips of the hairs.

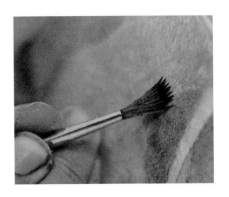

Right: *The paint is made lighter by adding water, and it is then used to put in very pale shadow areas.*

What does "wet-into-dry" mean?

"Wet-into-dry" is the term used for the process of applying a color wash over a dry color, as opposed to "wet-into-wet," in which the wet colors are allowed to bleed into each other while the painting is being completed.

How do I start painting a watercolor portrait?

To start this example, the artist began the painting by laying in a very diluted wash over the background and shadows of the face, hair and clothing. This was almost the same color, with very little variation between the skin tones and the background. She gradually introduced local color when building up with thin washes from light to dark in traditional watercolor manner.

1 Working on smooth watercolor board, apply a wash of violet, Indian red, and yellow ocher to the background. This will be strengthened later.

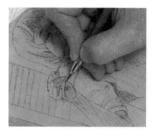

2 Lay the facial shadows in a combination of the background colors. These are slightly darker than the background tone, and will provide depth for subsequent washes.

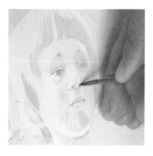

3 Touch up the shadows—and the eye—with the point of a No2 sable brush, in the traditional watercolor manner of dark-over-light (*see page 200*). Move across the image strengthening the tones.

4 Most of the painting is built up from violet, yellow ocher, and indian red. To retain the harmony of the composition, develop and strengthen the tones surrounding the brighter colors.

What does "dark-over-light" mean in watercolor painting?

Because watercolor is transparent, it is difficult or even impossible to paint a light color over a darker one successfully.

For example, face and flesh tones are often worked from light to dark if they are to be successful.

Above: *The artist uses the traditional "dark-over-light" watercolor technique to add shadow areas to the hair.*

Above: *Opaque white is used for tiny highlights. The artist uses "bleed-proof" paint for the narrow edge of light on the collar.*

Left: *In the finished portrait, a very dilute wash, representing the light areas of hair and the highlights, has been laid over the entire hair area and allowed to dry.*

ARTIST'S TIP

To stretch a paper, first soak it completely, either in a bath of water or under the tap. Lay the wet paper on a drawing board and tape the edges down with gummed paper strip. The paper should be allowed to dry naturally and will normally be ready for use after a few hours.

Can I paint a watercolor portrait from a live model?

In this example, the artist worked from a model to produce a watercolor in which the colors of the striped blanket in the background play a prominent role. Its charm lies in the delicate differences between overlapping areas of wash. The blanket is painted in subtle tones, and the shirt reduced to pale shadows. The first stage was a line drawing to act as a guide. A very pale, graded background wash was applied, starting with yellow and adding small quantities of cobalt blue. This gave a sense of dimension to the background.

1 The strong directional light on the model allows the artist to use the classical technique of allowing the white paper to represent highlights.

2 After making a light pencil drawing, start to apply pale washes of color to show the flesh tones and shadows on the clothing.

3 Use a darker flesh color for the middle tones of the hair. Add shadows in raw umber and payne's gray.

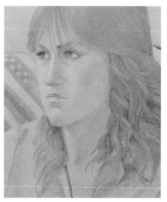

4 Strengthen tones to develop the form. When the basic tones have been established, block in the background, and sharpen the outline.

5 The imposition of the strong, dark background causes some of the figure tones to look weak and faded in comparison. To remedy this, strengthen some of the darkest shadows.

How can I suggest color in skin tones in watercolor washes?

Watercolor wash is the term used to describe the application of a layer of paint mixed with water onto the paper surface. Washes can be light or dark depending upon the ratio of water to pigment. In this painting, the artist captures the model's pale hair and complexion by using very delicate washes, and making the white paper do some of the work.

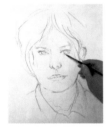

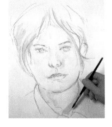

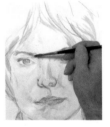

1 Draw the likeness with a 3B pencil. Paint in very dilute washes for the hair and flesh tints.

2 Add the shadow on the neck with a mixture of aureolin and viridian. Use a No7 sable brush throughout.

3 Paint the eyes, working around the highlights. Deepen the flesh tints and touch in the eyebrows.

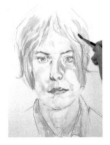

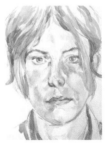

4 Deepen the color of the lips. Develop the hair. The eyes receive a deeper wash. Add one or two touches of a flesh tint along the jaw line and the shadowed side of the face.

5 Apply a pale wash of cadmium red to the skin above the upper lip.

How can thin washes be laid on top of each other in watercolor?

Thin, transparent layers of watercolor can be laid one on top of another giving the flesh a truly "flesh-like" feel and texture. Few other painting media can do this.

This painting exemplifies many of the more sophisticated ways in which watercolor may be used to create a strong but subtle portrait.

After the painting was completely dry, colored pencils were added in the face with light hatching strokes to strengthen outlines and shadows.

1 Put in the mid- and shadow tones with a thin wash. With a small brush, add eye details.

2 Add the eyes, nose, and mouth. If the paint is too wet, blot with a tissue and rework.

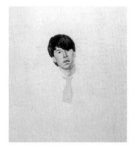

3 Apply a thin wash over the face. Work wet-into-wet with a light wash in shadow area.

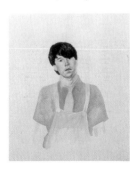

4 Block in shirt and apron with a thin wash, leaving the white of the paper for highlight areas.

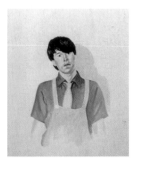

5 Darken hair color with burnt umber and a fine brush.

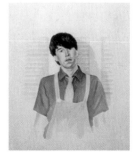

6 With red pencil, work light, diagonal strokes on the face, heightening warm areas.

How can I build up tones and textures with watercolor?

While this painting may prove difficult to think of as a serious portrait, it expresses some of the most attractive attributes of the medium. Despite its humorous aspect, the techniques and composition should not be overlooked. It is largely through the unique placement of the figure and the use of the clean, white space around it which forces the viewer's eye into the face of the subject. The strong darks of the hat and beard contrast boldly with the white of the paper, making it impossible not to look directly into the face.

1 Paint hat and beard. Keep the paint very wet and draw in outlines using tip of the brush.

2 With same color, define the eyes, nose, and mouth. Describe detail of hat in red.

3 Work over face and neck with a darker wash and a touch of red.

4 With a thin wash of gray, lay in shadow area of neck and chest.

5 Wet shirt area with water. Add a gray wash, and let tones run into the paper and one another.

6 While wet, work back into shirt with a thin wash; allow drops to fall from brush.

How can I make a quick watercolor portrait sketch?

A watercolor sketch may result in an interesting finished picture, or may be used as a reference for a larger work. In this picture, the effect is sketchy and shows a lively impression of the general form of the face and figure, lightly modeled with color and tone. The essence of the technique is to lay the color in watery pools which give the surface a loose, rippling texture. Generally, the paint is allowed to dry before each new color is applied in order to get the full effect of the overlaid color and liquid shapes. Many of the initial face and hair tones were laid using the wet-into-wet technique (*see page 198*).

1 Draw the subject lightly with a pencil. Work over hair and face with wet pools of color.

2 Wet paper in shadow areas of sweater, and drop touches of blue into them.

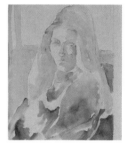

3 Strengthen the color over the whole image, to develop the structure of the forms.

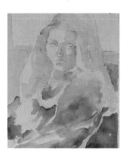

4 Model the face with heavy patches of red and brown.

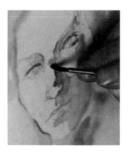

5 Draw in detail around eyes. Redefine eyes and mouth.

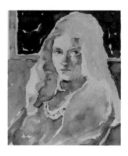

6 Add black to the background to bring the head forward.

How can watercolor be used with a quill pen to draw a portrait?

Watercolor paintings do not have to begin with a pencil outline. Drawing with watercolor using a pen can offer a looser, more intuitive finished study with the added advantage of an interesting, descriptive line in the finished work.

A quill pen, made from a goose feather, was used to make the initial drawing of this portrait. Quills are often used when a natural, undulating line is required, since by turning the quill it is possible to vary the width of the line, achieving a swelling and diminishing effect. Paint, watered down to a very thin consistency, was used with the quill in this case.

Above: This painting is concerned with the contours within the subject's face seen in a simple front view.

1 Use quill pen with diluted mixed watercolor: raw sienna and cobalt blue; prussian blue and cadmium red; cadmium yellow and yellow ocher.

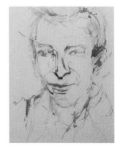

2 Color is drawn on the paper without any pencil drawing.

3 Mistakes are difficult to remove, but can be softened with water on a brush.

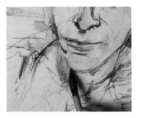

4 Selected areas of local color are applied with a Chinese brush.

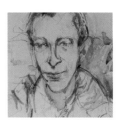

5 Work the background with a Chinese brush and a No9 sable round.

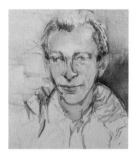

6 Light and tone are not important aspects of this portrait. The emphasis is on the linear and directional rather than a literal representation.

What is gouache and how is it different from watercolor?

Gouache is an opaque watercolor and is useful for quick color studies. It can also be used with watercolors and pastels to make complete paintings. It is usually regarded as better suited to landscape subjects than faces and experimentation will be necessary when attempting to render the human figure and skin tones.

Gouache contains a lot of chalk, or body color. This makes it opaque. With gouache it is possible to paint extremely light colors, or even white, over a dark base, provided the paint is not diluted too much.

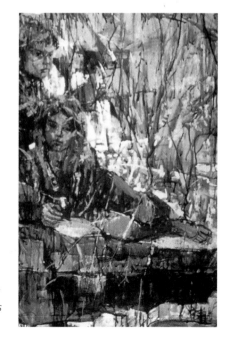

Right: *Anne Hicks,* Children by the Waterfall *(ink and gouache on brown paper). Each afternoon, when the park supervisor was out of sight, Anne would take her children to this waterfall and paint them through the leaves.*

How could I paint a portrait study in gouache?

Using gouache enables the artist to paint light colors over darker ones in a way that cannot be done with pure watercolor. The gouache gives a more solid effect, and a slightly chalky finish, particularly on the face tones, which have been blocked in with patches of thick opaque color. The face contains more detail than the rest of the picture, making it the focal point. The background has been left unfinished, suggesting a hazy though real interior.

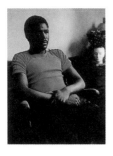

Above: The model is turned slightly, giving a three-quarter view to the artist.

1 Instead of starting with a preliminary pencil drawing, draw directly on the canvas with a brush and paint.

2 Develop the face as a series of tones. Change these until the likeness emerges from the lights and darks.

3 Strengthen outlines to ensure structure and form are not weakened or lost.

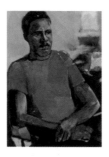

4 The composition has abstract qualities as well as a representational function.

ARTIST'S TIP

Too much water reduces the covering power of gouache, so take care to keep the paint at a thick, creamy consistency for maximum opacity. Dried gouache remains soluble. Wet paint may disturb the color underneath, although this is unimportant if painting in a loose style.

How can I paint patches of skin tones in gouache?

By studying this painting carefully, the relationships between form and color become apparent. Work small shapes of color, drawing with the brush to model curves and angles. A charcoal drawing is a helpful guide and can be used to redefine outlines if the paint is not too thick. Adding black to make shadows may dull a color; shadows on skin usually have a subtle cast of color such as green, blue, or purple. Contrast these with red and yellow within the lighter tones.

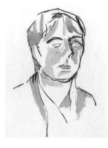

1 Draw outline with charcoal, indicating eyes, nose, and mouth. Lay thin washes of red and brown to indicate shadows.

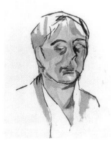

2 Identify basic colors in face and neck. Draw out contrasts by exaggerating tones slightly, overlaying patches of color.

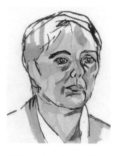

3 Draw into face with charcoal and paint in linear details with the point of a brush. Work features.

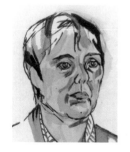

4 Alter head shape and lay in dark tones of hair. Paint scarf, strengthen red of the jacket.

5 Develop structure and color of face. Add white and pink highlights and brown shadow.

6 Block in hair and show strands. Reinforce shape of eyes and mouth with details.

EXPLORING
STYLES

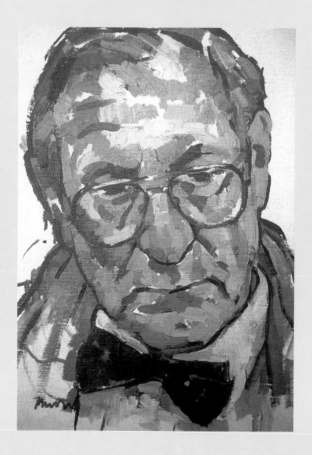

What does style in painting mean?

The number and variety of portraits drawn and painted over the centuries provides a fascinating source of imagery, lending insights into changing social conventions and tastes. They bear witness to artists' continuing attempts to depict the complexity and uniqueness of the human character and temperament.

When exploring the definition of "style," the words approach, method, manner, technique, mode, and way are used. Style in portrait painting can also be attributed to historical periods and the development of techniques, materials, and influences on or fashions of painting during these periods.

What is the difference between a formal portrait and an informal portrait?

Most, if not all, society portraiture celebrates wealth, charm, and power. Official portraiture celebrates power and achievement. These forms are usually commissioned and almost always closely follow traditional lines.

The informal portrait offers intimate insights into the psychology of a friend, relative, or lover. These are usually uncommissioned.

Some portraiture is highly imaginative, stylized, or distorted, and artists wrest a likeness from the sitter by a tortuous painterly process, producing great art as well as great portraiture—perhaps a portrait of our times as much as an individual likeness.

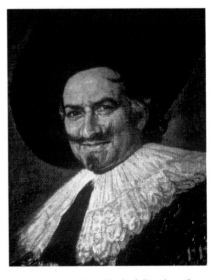

Above: *Jerry Hicks,* Orlando *(oil on board). Formal meets informal: This was one of several "old master" ancestors, painted with the likeness substituted as a joke.*

How can I paint more unusual portraits?

In the past century, the attitude of many artists toward portrait painting has undergone profound changes. Picasso's Cubist portraits radically remade the genre. Besides the Cubist fragmenting and faceting, there have been portraits in striking color, as in Matisse's Fauve portraits. Highly imaginative, even bizarre portraits by Surrealists, such as Salvador Dali and Frida Kahlo, have taken us into the realms of Freudian psychology and dream; while in the anxious years of the Cold War, Francis Bacon produced screaming heads and troubling self-portraits. But throughout, none of the artists has avoided the challenge of rendering a likeness.

These great artists produced superb portraits but they did not have to earn their living by their trade. Many lesser contemporary artists fall into this category and some straddle both, partly working for commissions, but also to satisfy a sense of curiosity or adventure.

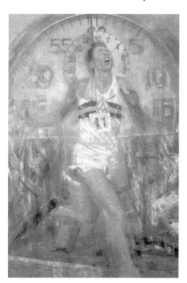

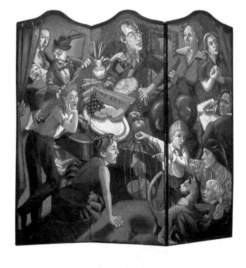

Above: *Jerry Hicks,* Roger Bannister Breaking the Four Minute Mile Barrier *(oil on board). This portrait won a Queen's Silver Jubilee Award in Great Britain for a painting of a great British achievement.*

Above: *Hugh Dunford Wood,* Family Portrait *(acrylic on leather). The artist built the composition from drawings of the individuals and then finished with sittings.*

How can using a mirror to add reflections make the portrait more interesting?

The use of mirrors in painting and portraiture has a long history. At its simplest, the mirror reflects what is before it. However, in painting it can serve to add another dimension to the work by allowing us to see objects or situations outside the picture plane and thereby extending the nature of the two-dimensional surface.

It is important to be aware of the fact that all painting is an illusion. However, in portraiture, a degree of realism is required to capture the uniqueness of the individual. The use of realism in painting is an attempt to create an illusion. The artist is presenting a picture as if the viewer were looking through a window onto the presented scene.

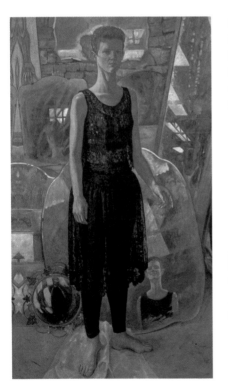

Left: *Ros Cuthbert,* Self-Portrait with Mirrors *(oil on board). The pose was inspired by Goya's painting of the* Duchess of Alba. *The mirrors are partly from photographs taken in a junkyard and partly from life, and the reflections are reinvented.*

ARTIST'S TIP

The mirrored reflection can either be the focal point of the painting or a secondary element within the canvas. The reflections can be actual, or invented, e.g. to showcase a particular attribute or hobby of the sitter, or to reflect the hopes and aspirations of the artist, and so on.

How can I explore the art of caricature in portraits?

Caricature is a type of visual shorthand designed to provoke, through exaggeration, some sort of response — recognition mixed with amusement at the very least, although social or political comment is often implied too. Like portraiture, the essential prerequisite is the ability to capture a likeness; the dividing line between portraits and caricatures is not always clearly defined. In general, however, caricaturists isolate and distort the characteristic features of their subjects and are concerned not only with revealing personality but also with the social context. Many artists have shown a fascination with caricature: Leonardo da Vinci, for example, made

many drawings of distorted faces, revealing a preoccupation with oddity and disharmony almost as strong as his interest in perfection and beauty. True portrait caricature emerged in the late sixteenth century, but not until the eighteenth century, with the work of James Gillray (1757–1815) and Thomas Rowlandson (1756–1827), was political caricature established as a genre. The French caricaturist Honore Daumier (1810–79) was one of the greatest exponents of this art form. Caricature is dependent to a large extent on line; this linear quality is particularly important for examples designed to be reproduced in newspapers and magazines.

How can I paint in an unusual format?

The shape of the support will affect the nature of the image: if the subject involves any horizontal or vertical divisions, they can be related to the boundaries of the paper and so provide a form of visual echo which will give the drawing a stability and unity. Circular, square, or irregularly shaped surfaces demand different compositional considerations, but can be used to good effect. (*See also page 213.*)

Above: *The style of a Roman coin could make for an interesting profile portrait.*

How can I use color to explore style?

Color will always be a challenge to the portraitist. At first sight it would appear that a portrait would be dominated by flesh tones. This, though, is not always the case, as witnessed in the portraits by Derain, Matisse, and the candle-lit flesh tints of a de la Tour. By deciding upon a color idea—that is, a scheme of color that both harmonizes and reflects the feelings one has towards the subject— the picture will get off to a good start. An elegant lady with jewelry and silks will need a different color idea than that used in painting a baby or the noble head of an old man. Flesh itself varies in color a great deal from the pink blush in a Fragonard (1732–1806), to the dry tints in a Wyeth, or the modulated tones in a Franz Hals (1585–1666).

To experiment with the mixtures that might result in descriptive flesh tones is essential, and to use a mixture of techniques desirable. Limited palettes for flesh painting have always proved most successful. A good, general palette that will mix in several ways would consist of yellow ocher, light red, terre verte, cobalt blue, and flake white. By mixing the yellow and red with perhaps a touch of terre verte or blue, a good general tint will be achieved. By using this limited palette, discoveries will be made as to how red and blue, or blue and green, or any other multi-mixtures, will correspond to the colors seen.

Shadows should be carefully analyzed so that when painted in they are never simply a darkened version of the general color in the lighter areas; each shadow has its own color and tone. The shadows in the face and hands or any other flesh areas will be affected by external colors being reflected into them. Thus, the shadow on a nose might well have a green cast to the color whereas the darker, warmer tones beneath the eyebrows might contain a purplish-brown. By experimenting with both the "reflected" shadow colors and the local, lighter colors, one will discover the value of understanding and using the various color theories.

ARTIST'S TIP

The use of personal color evolves throughout an artist's career, mostly through the experience of painting. To explore your own color style direction, make a few color portrait head and shoulder sketches in a series. You could use the same model or photograph for these and paint the faces in an overall flat skin tone without features. Using the correct tones in the model's clothing, in the first series use mostly cool colors in the clothing and backgrounds, in the second series, use overall neutral colors in the backgrounds and clothing, and in the third series use mostly warm colors in the backgrounds and clothing.

After you have explored these options, decide which of these series best reflects your personal color preferences and vision.

Can you give me more examples of how I can use color to affect the style of my work?

Choosing to use the palette colors of artists you admire will influence your work. Here are two examples of how color can be used as a major force in a portrait. Both artists use color in the skin tones in a unique and expressive way.

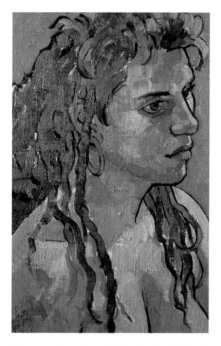

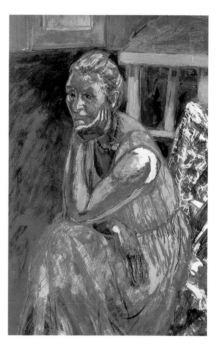

Above: *Robert Maxwell Wood,* Girl with locks *(oil on canvas). This artist always uses the same palette setting which he keeps permanently on his palette. The pigments used here are cadmiums yellow, lemon, orange and red, Rowney rose, transparent violet, cerulean blue, ultramarine blue, viridian, cadmium green, and cremnitz white.*

Above: *David Cuthbert,* Portrait of Denise *(acrylic on paper). In this vibrant portrait, linework has been kept very separate from modeling. The head rests heavily on the left hand, the back of which is one of the darkest areas in the picture.*

How can I paint an imaginary portrait?

A few years ago, the artist Ros Cuthbert almost had the chance to paint the envoy of Britain's Archbishop of Canterbury, Terry Waite, but he was abducted in Beirut before the first sitting.

While waiting for his release, she began drawing imaginary studies helped by photographs from the press. As time went by and he remained a hostage, she began to conceive a series of imaginary portraits. The project eventually grew to a series of more than twenty paintings— *Portraits of a Hostage.*

Although a difficult time, it was very productive. She discovered how to combine imaginative processes with portraiture and this has been useful ever since—though she never got to paint Terry Waite himself.

 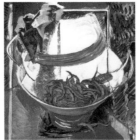

Above: *Ros Cuthbert,* The Hostage—Bread, The Hostage—Beans, and The Hostage—Salt *(all oil on canvas). Three from a suite of six in which British envoy Terry Waite's head is portrayed with produce from Lebanon.*

Right: *Helen Elwes,* The Green Woman—a Self-Portrait *(egg tempera on board). Helen finds that tempera lies somewhere between drawing and oil painting. She likes to use it for composition studies. In this portrait she sees herself in relation to nature, connecting with the pre-Christian symbol of the Green Man.*

Are there any more suggestions for how to develop a personal way to depict a subject?

By looking at any portrait painter, it will be apparent that each one found a personal way of selecting from the numerous possibilities evident in reality.

It is often easier to start with a simple format of one figure situated against a simple background. With experience, it may be possible to gradually involve other objects that reveal clues about the identity of the sitter. These may take the form of a direct reference to the sitter's occupation or personal interest; alternatively they may simply suggest an interior space, for example, a domestic environment. Many painters have used landscape backgrounds for portraits or a combination of both interior and exterior by the use of a window. The possibilities are endless and yet every situation demands an understanding of the relationship between the shape of the figure and the surroundings.

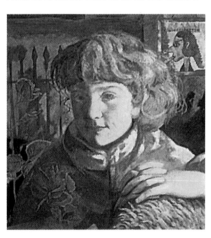

Above: *Ros Cuthbert,* Evening at Knightstone *(oil on canvas). This portrait is based on a photograph of the artist's daughter taken when, one winter afternoon, they found themselves waiting in a car by the ocean.*

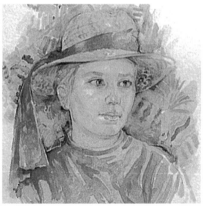

Above: *Pat Hares,* Lucinda *(watercolor). The artist worked on this painting in the evening light, using 200 lb cold-pressed paper, unstretched. She made several free studies with the brush, then began the painting with pencil. The wash for the face was mixed with light red and cadmium yellow and was painted more or less in one session.*

Abstract Relying on color and form rather than the realistic or naturalistic portrayal of subject matter.

Acrylic A paint in which the pigment is suspended in a synthetic resin. It is quick-drying, permanent, and colorfast.

Advancing colors Colors that appear to stand out, because they are brighter, stronger, or denser than their neighbors.

Aerial perspective The use of color and tone to denote space and distance.

Alla prima Direct painting in which the picture is completed in one session without underpainting or underdrawing.

Binder Any liquid medium that forms a paint when mixed with powder pigment.

Blending Merging colors together in such a way that the joins are imperceptible.

Blocking-in The initial stage of a painting when the main forms and composition are laid down in approximate areas of color and tone.

Broken color Paint applied in its pure state rather than being mixed. This stiff paint is usually applied by dragging the brush across the surface, allowing layers of color underneath to show through.

Chiaroscuro The exploitation of light and shadow within a painting.

Collage A picture made up from pieces of paper, fabric, and other materials glued onto canvas, paper, or other support.

Composition The arrangement and combination of different elements to make a picture.

Complementary colors Colors that appear opposite each other in the color circle. Hence, purple is complementary to yellow, green to red, and orange to blue.

Cross-hatching A method of building up areas of shadow with layers of criss-cross lines rather than with solid tone.

Fixative Thin varnish which is sprayed on drawing media, especially charcoal and pastel, to prevent smudging and to protect the surface.

Glazing Painting a transparent film of color over another pigment.

Ground Substance painted onto a surface to make it suitable for painting on. With oil painting, for instance, the ground is usually gesso or an oil-based mixture.

Gum arabic Used with watercolor and inks to give body and sheen.

Gum water A solution of gum arabic used with inks and watercolors to provide extra sheen and body.

Hatching A shading technique which uses parallel lines instead of solid tones to build form.

Impasto The thick application of paint or pastel to the picture surface in order to create texture.

Lean A term used to describe oil color that has little or no added oil. The term "fat over lean" refers to the traditional method of using "lean" color (paint thinned with turpentine or mineral spirit) in the early stages of a painting and working over this with "fat," or oil paint, as the painting progresses.

Linear perspective A system for drawing space and objects in space on a two-dimensional surface. It is based on the fact that parallel lines going in any one direction appear to meet at a point on the horizon. This point is referred to as the vanishing point.

Local color The actual color of the surface of an object without modification by light, shade, or distance.

Mask A device used to prevent paint or any other medium from affecting the picture surface in order to retain the color of the support or the existing paint in a particular area.

Masking The principle of blocking out areas of a painting to retain the color of the support. This is usually done with tape or masking fluid and leaves the artist free to paint over the masked areas. The masks are removed when the paint is dry to reveal the areas underneath.

Masking fluid A rubber solution which is painted onto a picture surface to retain the color of the paper or support. When it is dry, the artist can paint safely over the masked areas. The mask is removed by rubbing it with an eraser or finger.

Medium In a general sense, the medium is the type of material used, such as oil paint or charcoal. More specifically, a medium is a substance mixed with paint or pigment for a particular purpose or to obtain a certain effect.

Mixed media The technique of using two or more established media, such as ink and gouache, in the same picture.

Monochrome A painting done using black, white, and one other color.

Negative space The space around the subject rather than the subject itself.

Opacity The ability of a pigment to cover and obscure the surface or color to which it is applied.

Optical mixing Mixing color in the painting rather than on the palette. For example, using dabs of red and yellow to give the illusion of orange rather than applying a pre-mixed orange.

Picture plane Area of a picture that lies directly behind the frame and separates the viewer's world from that of the picture.

Planes The surface areas of the subject which can be seen in terms of light and shade.

Primary colors In painting these are red, blue, and yellow. They cannot be obtained from any other colors.

Primer The first coat on the support over which other layers—including the ground—are laid.

Saturated color Color with a high degree of purity. The degree of saturation is assessed by comparing it with a colorless area of equal brightness.

Size A solution such as rabbit skin glue used to prepare the surface of the canvas or board before priming or painting.

Stencil A piece of stiff material from which a motif has been cut. A pattern is made by painting through the hole.

Stipple Painting, drawing, or engraving using dots instead of line or flat color. A brush is available for stippling paint.

Support Surface for painting or drawing on, usually canvas, board, or paper.

Torchon (tortillon) A stump used for blending charcoal and pastel. This is often made of rolled paper or chamois.

Underdrawing A preliminary drawing for a painting, often done in pencil, charcoal, or paint.

Underpainting The preliminary blocking-in of the basic colors, the structure of a painting, and its tonal values.

Wash An application of ink or watercolor, diluted to make the color spread transparently and evenly.

Wet-into-dry The application of paint to a completely dry surface causing the sharp overlapping shapes to create the impression of structured form.

Wet-into-wet The application of paint to a surface that is still wet to create a subtle blending of color.

Image credits